# BETHANY BEACH

# BETHANY BEACH

## A BRIEF HISTORY

MICHAEL MORGAN

Published by The History Press
Charleston, SC 29403
www.historypress.net

Copyright © 2010 by Michael Morgan
All rights reserved

*Cover image by Gwyneth Anne Jones, "The Daring Librarian," www.thedaringlibrarian.com.*

First published 2010
Second printing 2013

Manufactured in the United States

ISBN 978.1.60949.002.7

Library of Congress Cataloging-in-Publication Data

Morgan, Michael, 1943-
Bethany Beach : a brief history / Michael Morgan.
p. cm.
Includes bibliographical references.
ISBN 978-1-60949-002-7
1. Bethany Beach (Del.)--History. I. Title.
F174.B45M67 2010
975.1'7--dc22
2010019883

*Notice*: The information in this book is true and complete to the best of our knowledge. It is offered without guarantee on the part of the author or The History Press. The author and The History Press disclaim all liability in connection with the use of this book.

All rights reserved. No part of this book may be reproduced or transmitted in any form whatsoever without prior written permission from the publisher except in the case of brief quotations embodied in critical articles and reviews.

# CONTENTS

Preface     7

**Chapter 1. Land of the Kuskawaroaks**
Nanticokes on the Indian River     9
Edmund Andros Pushes Sussex     12
An Eerie Silence on Indian River     15
John Watson Draws a Line     17
Murder on the Border     20

**Chapter 2. Revolution to Rescue**
Salt of the Sea     23
Fugitive by the Ocean     26
Tragedy of the *Faithful Steward*     30
A Dab of Color on the Beach     33
Leader *Par Excellence*     36
Gamble of the *Red Wing*     39

**Chapter 3. Bethany Blossoms at the Beach**
Tabernacle in the Sand     43
The Long, Long Road to Bethany Beach     47
Bethany Builds     51
Bathing More Refreshing     59
Drexler's Dream     64

## Contents

**Chapter 4. Diggers and Shakers**
Modern War off Bethany ... 71
Coast Artillery Fires Up ... 74
Blast before Election Day ... 79
Bootleggers Challenge the Coast ... 83
A Chicken in Every Pot ... 85

**Chapter 5. Bethany at War**
Towers along the Coast ... 89
Five Gallons of Sand ... 94
Enemy on the Beach ... 95
Drexler's Sacrifice ... 99

**Chapter 6. Towns Grow Together**
Shining Memory of the Indian River Inlet ... 101
Storm over the Coast ... 105
The Search for Margaret Kincade ... 109
Splendid Concerts and Solos ... 111
The Kuskawaroaks Look to the Land ... 113

Bibliography ... 119
About the Author ... 127

# PREFACE

The Delaware coast from the Indian River south to Bethany Beach and westward to the coastal towns of Ocean View and Millville is one of the most pleasant areas in America. From the time that the Nanticokes first visited the region several hundred years ago to today, visitors to this part of the coast have found a quiet respite from the usual hubbub of daily living. In addition to enjoying the sun, surf and sand, the calm atmosphere of Bethany Beach encourages residents and vacationers to contemplate the many people who have tread these shores during the area's long history. This work provides a glimpse of some of these folks and what they did.

This book would not have been possible without the support of Hannah Cassilly at The History Press. I would also like to thank my son, Tom, who serves as my technical advisor for all computer issues. Finally, I would like to thank my wife, Madelyn, for her constant editorial advice and support. She read every word in this book numerous times and spent countless hours correcting my spelling, punctuation and grammar. Whatever errors remain are mine.

# Chapter 1
# LAND OF THE KUSKAWAROAKS

## Nanticokes on the Indian River

Long before Bethany Beach, Ocean View, Millville and other coastal communities were established, the land between the south shore of the coastal bay and the Indian River Inlet was filled with rabbits, deer, bears, birds and other wildlife. Laced with creeks, streams and meandering trails, the wide stretch of land began at the Great Cypress Swamp and ended at the surf's edge. Four centuries ago, this was the home of the Native American tribe the Kuskawaroaks.

Writing in 1987, Little Owl (Charles C. Clark IV) commented:

> *The meaning of Kuskawaroak is unknown but it is possible it means "place of making white beads."…Records show that we have also referred to ourselves as being the Nentego, as well as Nantaquak. Undoubtedly, the recognizable "Nanticoke" is a derivation of Nantaquak. "Nanticoke" translates to mean "people of the tide waters," or "people who ply the tidewater trade." Today, the Kuskawaroak are most often referred to as the "Nanticoke."*

The time that the Nanticokes arrived on the south shore of the Indian River is uncertain, but they occupied this land for many years. Little Owl noted:

> *Countless centuries ago, large numbers of Native Americans began a mass exodus across the country traveling in all directions. The group of people*

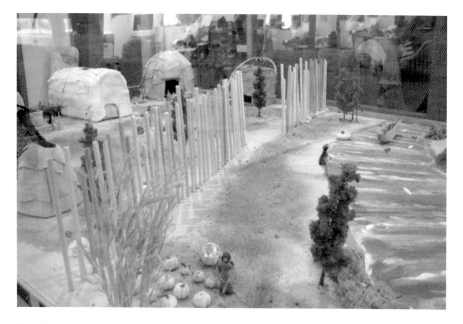

The Nanticokes lived on the shores of the Indian River long before John Smith arrived. *Diorama, Nanticoke Indian Museum. Photo by Michael Morgan.*

*which moved eastward became known as the Algonquian Migration, as we all spoke dialects of the Algonquian language. The Nanticoke were among these people.*

The Nanticokes built permanent homes, known as wigwams or witus, out of wood and bark, with reed mats covering the floor. Some of these structures were small, domelike buildings, and others were rectangular. In addition to their permanent inland homes, the Nanticokes built seasonal houses closer to the coast. During the hot summer months, they used these "vacation" homes along the Indian River and near the beach to take advantage of the cool sea breezes. While staying in this area, the Nanticokes launched their dugout canoes into Indian River Bay, where they caught fish, crabs and oysters.

The Nanticokes were an autonomous Algonquin tribe who occasionally formed alliances to deal with long-standing conflicts. In 1608, however, the Nanticokes were at peace when Captain John Smith and a small band of English colonists boarded a small boat at the fledgling Jamestown colony. Short and stubby, with a broad, red beard, Smith was still in his twenties and had already led a full life. A true soldier of fortune, Smith had enlisted with

## Land of the Kuskawaroaks

a Slovenian warlord and fought in Transylvania, where he claimed to have beheaded three Muslims. Shortly afterward, however, Smith was captured and sold as a slave. Fortunately, his new owner happened to be the beautiful daughter of a Greek noblewoman, who attempted to shield him from abuse by turning him over to her brother. The plan backfired; after suffering several months of harsh treatment, Smith escaped and made his way back to England, where he sought further adventures as a member of the original Jamestown colonists, who set sail for America in 1607.

The settlement at Jamestown had just been established, but the energetic Smith chafed at the lethargic progress at the small settlement. Smith was the personification of European self-confidence and arrogance, and he wanted to learn more about the Chesapeake Bay and the surrounding area. On June 2, 1608, he guided a boat with fourteen other colonists down the James River and across the Chesapeake Bay, where he began to explore the rivers and streams of the Delmarva Peninsula. As he headed northward, a thunderstorm swept over Smith's small boat, and he later recalled:

> *The wind and waters so much increased with thunder, lightning, and rain that our mast and sail blew overboard and such mighty waves over-racked us in that small barge that with great labor we kept her from sinking by freeing* [bailing] *out the water.*

The resourceful Smith stubbornly continued his exploration: "Repairing our sail with our shirts, we set sail for the main and fell with a pretty convenient river on the east called Kuskawaroak." As Smith's small boat navigated the twists and turns of the river, word spread among the Native Americans of the arrival of the Englishmen.

It had been more than a century since the first voyage of Christopher Columbus and the initiation of the European invasion of the Americas. During that time, most of North America had been ignored by the newcomers from across the sea. The Spanish had established settlements in Florida, and France was active in Canada, but most of the continent had seen only fleeting visits by Europeans sailing along the coast. The Nanticokes who spotted John Smith's small boat, however, traded with tribes far beyond the Delmarva Peninsula; they undoubtedly heard stories about the fair-skinned people who had been moving onto tribal lands as if it were their own.

The Nanticokes were distrustful of the small boat of fair-skinned explorers, and the Native Americans acted to defend their homeland. According to Smith:

*The people ran as amazed in troops from place to place, and divers got into the tops of trees, they were not sparing of their arrows, nor the great passion they could express of their anger. Long they shot, we still riding at an anchor without* [beyond] *their reach making all the signs of friendship we could.*

The Nanticokes failed to drive the Englishmen away, and the encounter with John Smith's small party began the slow disintegration of the Native American hold on southern Delaware. After he returned to England, John Smith published an account of his voyage up the Nanticoke River. In addition, he drew a map that included the serpentine course of the river as it winds its way from the Chesapeake Bay to southern Delaware. It is not clear how far up the river Smith traveled, but it is believed that he traveled as far as Broad Creek, and he may have journeyed as far as the Seaford area.

In the ensuing years, other colonists would retrace Smith's route to settle in Sussex County, where they cleared the forests and planted tobacco, corn and other grains. The European settlers were scattered throughout the region, but as their numbers grew they soon outnumbered the Nanticokes. In addition, some of the descendants of these colonists would one day establish the coastal towns of Ocean View, Millville and, eventually, Bethany Beach.

## Edmund Andros Pushes Sussex

In 1631, the Dutch had established a settlement near Cape Henlopen, but that colony was destroyed in a dispute with a local Native American tribe. The destruction of the initial European settlement near Cape Henlopen did not dissuade small groups of Dutch and Swedish colonists from settling along the Delaware. After losing a war with Great Britain, the Delaware settlements fell into English hands under the immediate direction of the Duke of York, who lived far from the land of the Nanticokes but claimed it as his own.

Although the Dutch and Swedish settlers had been subdued, the duke's new holdings were being infiltrated by settlers from Maryland and other neighboring colonies that were threatening to swallow up most of Delaware. Some dissatisfied Virginia colonists sailed north along the Delmarva Peninsula until they reached the Indian River Inlet, which led them to the attractive land on the western shores of the coastal bays. In addition, Lord Baltimore of Maryland believed that his colony extended to the shore of Delaware Bay, and he did not hesitate to grant considerable tracts of land

## Land of the Kuskawaroaks

to prospective colonists. Marylanders pushed up the Nanticoke River, and they took possession of the ancestral land of the Nanticokes in western Sussex County.

Near the Atlantic coast, the early European colonists ignored the land close to the beach in favor of higher land several miles to the west where the ground was firm, fertile and free from the wind-blown salt air. There were also rich stands of timber, which provided the raw material for houses, fences and other necessities. In 1688, Lord Baltimore granted Matthew Scarborough a tract of five hundred acres of land around White's Creek that he called "Middlesex."

Precisely why Scarborough wanted this particular slice of coastal territory is not known. In the late seventeenth century, there were few people living on the low plain that separated Indian River and Little Assawoman Bays. As the Nanticokes had discovered centuries earlier, the wide neck of land that connected the beach with the mainland provided an excellent land route to the coast, and Scarborough may have also felt that his Middlesex grant would provide a convenient stopping place for boats traveling north and south through the coastal bays. In addition, the Indian River Inlet provided easy access to the Atlantic Ocean, and boat traffic could increase the value of Scarborough's tract. For many years, the idea of the White's Creek area becoming a busy crossroads lined with scores of businesses to serve hordes of travelers remained only a pipe dream.

Scarborough received his grant from Lord Baltimore, who believed that his Maryland colony extended northward to Cape Henlopen. When he discovered Dutch settlers living near the cape, Lord Baltimore sent armed men to the village on Lewes Creek to demand that the settlers acknowledge him as their proprietor. The first visit consisted of just a few men, and the Dutch colonists were able to put off the emissaries' demand. In 1673, three dozen armed Marylanders returned to the settlement, and they burned the village to the ground.

Some of the Dutch colonists at Lewes rebuilt their small homes, and they prepared for Lord Baltimore's next onslaught. In 1674, the Treaty of Westminster formally transferred Delaware from Dutch to English rule; when the Duke of York acquired title to the coastal region, Lord Baltimore was faced with a more formidable foe.

After he acquired Delaware, the duke appointed Edmund Andros as the governor of the colony. Andros was a young and ambitious member of an aristocratic English family. He first came to America as an officer in an infantry regiment that had been dispatched to the West Indies in 1666 during

a war with the Dutch. Six years later, Andros used his wife's family connections to acquire a vast tract of land in the Carolinas. Although he was a major landowner, Andros showed little interest in establishing a plantation on his newly acquired estate. The bold and decisive Andros was interested in political power. When the Duke of York began to search for a man to govern the former Dutch holdings in America, he looked no further than Edmund Andros.

When he assumed control of the Delaware settlement, Andros allowed the colonists to retain some of their local customs, but he initiated some English institutions. Constables and sheriffs were appointed to replace Dutch officials, and county government began to follow a more English model. After dealing with the former Dutch settlements near Delaware Bay, Andros looked to the southern border of the colony.

When Andros became governor, the Duke of York and Lord Baltimore agreed that the southern boundary of the Delaware colony was at Cape Henlopen, but Andros sought to enlarge the Duke of York's holdings. The new governor gave to English colonists grants of land on the banks of the Indian River and its southern tributaries. After English settlers established farms on these land grants, their presence deterred the Marylanders from making direct attacks on the Delaware settlements. At the same time, Andros began to question the location of Cape Henlopen. Some maps placed Cape Henlopen at the bulge in the coast near Fenwick Island instead of at the mouth of Delaware Bay.

A few years after he acquired Delaware, the Duke of York turned his holdings on the Delaware Bay over to William Penn, and Andros moved on to the other duties. During his short term, however, he had planted the seeds of expansion for Sussex County. After Penn took control of Delaware, he began a vigorous campaign to push two dozen miles southward past the Indian River Inlet into the land of the Nanticokes on the south shore of Indian River Bay.

When the European leaders carved up North America and established colonies in the seventeenth century, their knowledge of coastal geography was a bit wanting. In 1632, the king of England granted Lord Baltimore the colony of Maryland, which was to include the land between the Potomac River and the fortieth parallel of latitude. This included all of the land along the Delaware-Atlantic coast, and it set the northern border of Maryland to the vicinity of Philadelphia. William Penn, however, was not about to let the details of geography confine his colony.

After Penn arrived in America, he met with George Calvert (the third Lord Baltimore) to discuss the borders of their colonies. Penn put forth the

geographically unfounded claim that the fortieth parallel was twenty-five miles farther south than it was shown on most maps. After arguing about what type of quadrant should be used to measure the fortieth parallel, the meeting collapsed without resolving the issue. Fifty years later, the two sides were still arguing the borders between the colonies when Charles Calvert (the fifth Lord Baltimore) met with the sons of William Penn to negotiate the southern border of Sussex County. Both parties agreed that Cape Henlopen marked the southern border of Delaware. At the meeting, a map was produced that showed Cape Henlopen as a bulge in the coast at Fenwick Island, and Charles Calvert agreed to this as the starting point of the border. When he discovered that he had given away two dozen miles of prime oceanfront land, as well as the sites of the coastal towns, Calvert appealed to the courts to reverse the decision, but they ruled against him. Lord Baltimore's faulty geography had cost Maryland a beautiful resort at Bethany Beach.

## AN EERIE SILENCE ON INDIAN RIVER

While Calvert, Penn and other colonial leaders squabbled over the border between Delaware and Maryland, an eerie silence had settled over the Nanticoke villages near the Indian River, and in June 1742, the European settlers were nervous. The Nanticoke men, women and children quietly left their southern Delaware homes and slipped south into Maryland. As one settler pointed out:

> *Indians have all left…under a pretense of hunting, which I think seems to be a slender excuse, and ought not be credited. For if they only intended to hunt, they would not carry with them all the old men, women and children that could not be of any service to them in hunting, but would have left them at the towns to take of their cornfields etc. They have carried away all their goods…and all of their corn* [has been] *destroyed, which they would have taken care to preserve, had they designed to have lived in the same peaceable manner as heretofore they did live.*

When the Nanticokes reached an isolated swamp along the Pocomoke River, they were joined by hundreds of others who were determined to stem the flood of Europeans who were forcing them off their land.

According to a statement located in the Maryland Archives by a Native American known as Patrick:

> *About the middle of May past, he saw at Chicacoan, a town on Nanticoke River, 23 Shawan Indians and about a fortnight afterwards the Nanticoke Indians sent for him and the rest of the Choptank Indians to follow them to a certain place near Pocomoke Swamp, where they came and found all of the Somerset County Indians gathered together; and he was told by the Great Men that the Shawan Indians was to come down some time this present Moon to join them and kill all the English by surprise in the night.*

When the Nanticokes arrived in the Maryland swamp, they discovered a log house that was being turned into an armory. According to one eyewitness, the building was

> *about 20 feet long and 15 feet wide…for a repository to secure their arms and Ammunition, and they now in the said house have several guns with a good deal of ammunition and a large quantity of poisoned arrows point with brass, and that they intended to begin the attack…at several places in one and the same night and…to destroy man, woman and child as far as they extended their conquest.*

The deadly arrows were the work of a Native American from Sussex County. According to a Native American named Anthony, "An Indian River Doctor had prepared a great deal of poison to destroy the English and that [when] he left the said doctor [was] boiling poison" in the Pocomoke Swamp. Anthony also reported that

> *a great quantity of Indians in company with a war captain of the Shawnee Indians together with twenty more of that nation, who continued dancing for six nights together with drums beating, firing of guns and tomahawks in their hands, acting in a warlike manner, the Shawnee Indians often saying that the Englishmen were like children and knew not how to fight.*

After the meeting, the Native Americans from southern Delaware returned to their homes, where they were to wait until "Apple time," when the great uprising was to occur. The Maryland authorities, however, discovered the plot and arrested a number of the Native American leaders. When the Indians were interrogated, they denied that they were planning any actions against the English settlers. In addition, they denied the existence of poisoned arrows. One of the Native Americans testified: "While he was at the swamp, he drank some of the liquor prepared by the Indian River Doctor to do his

stomach good and keep off a fever." Eventually, all of the Native Americans who had been arrested were released by the Maryland officials, who declared, "We are rather desirous to use you kindly like brethren in hopes that it will beget the same kindness in you to us."

Having failed in their efforts to resist the European occupation of southern Delaware, some of the Nanticokes accepted an offer from the Six Nations of the Iroquois, who lived in New York, Pennsylvania and Canada. The Iroquois had once been the enemy of the Nanticokes, but they promised the Delaware Indians both land and protection. Many of the Nanticokes accepted the offer of the Iroquois, others moved to land along the Susquehanna River and some traveled to the West. A significant number of Nanticokes, however, moved eastward into Delaware and settled in Indian River Hundred, where they purchased land and assimilated into the predominant culture.

## JOHN WATSON DRAWS A LINE

When John Watson left Philadelphia on December 13, 1750, his saddlebags were packed with notebooks and new surveying equipment. The tall, heavyset man guided his horse southward along the rutted dirt road that led to Delaware. He would take a week to reach Fenwick Island, where there would be little protection from the numbing cold of the winter weather. Watson had served as the deputy surveyor for Bucks County, and he once preferred to go barefooted as he foraged over the rugged Pennsylvania countryside. After his father died of a rattlesnake bite, however, Watson always wore a set of heavy boots while surveying in the woods.

The tough Pennsylvanian surveyor also dabbled as an attorney and had a fondness for poetry. On one occasion, a man who had been arrested for stealing a halter turned to Watson for help. Although there was significant evidence against the accused thief, the man begged Watson to defend him. In an eighteenth-century equivalent of "If it does not fit, you must acquit," Watson appealed to the jury in impromptu verse and won his client's acquittal.

Five days after he left Philadelphia, Watson arrived at Lewes, where he spent the night before beginning the final leg of his trip to the land south of the Indian River. Watson arrived on Fenwick Island in December 1750 to mark the line that would determine if Bethany Beach, Ocean View and other coastal towns would be part of Delaware.

When John Watson arrived on Fenwick Island on December 20, he was joined by fellow surveyor William Parson. Watson and Parson had been

appointed by William Penn to help settle the boundary feud that had been simmering for more than a century. Despite the bad weather, John Watson's surveyor's eye allowed him to appreciate some of the natural beauty of southern Delaware. On December 20, 1750, Watson wrote in his journal:

> *This morning…Parsons, Shankland and myself set out for the cape early where we arrived about noon, and found the Maryland gentlemen & surveyors on Feni,* [Fenwick] *Island but soon left it the weather being very stormy…In this day's journey, which was through the rain, the land not very good, and the swamps beautified with holly some of which were 20 inches over at the least.*

When Watson reached the southern tip of Delaware, the weather began to deteriorate; the surveying team was forced to retreat inland, where they found better protection from the cold. It was not until December 24 that the surveyors were able to return to the coast, where they started work. Starting a cedar post near four mulberry trees, Watson and the others made astronomical observations and measurements, which were described in the nineteenth century by historian John H.B. Latrobe:

> *The mode of proceeding was to measure with the common chain, holding it as nearly horizontal as they could, the directions being kept by sighting along poles, set up in what they called "vistas," cut by them through the forest.*

After working for over a week, the surveyors decided to build a small cabin on Fenwick Island so that they would not have to go back to the mainland every night. Watson and the others equipped their small beach shack with a fireplace, and they furnished it with cozy bedding of bearskins and sheepskins. Four days later, however, a spark from the fireplace ignited the shack, and within minutes it was burned to the ground. After spending a frigid night on the beach, Watson returned to more permanent lodgings on the mainland. Fortunately, the surveyors lost none of their notes in the fire, and they were able to continue work on the boundary line.

After completing the line across Fenwick Island, the surveyors began to move inland, where frigid weather aided them in their work. On January 9, Watson wrote in his journal:

> *This morning the air* [is] *a little calmer but extreme cold…We proceeded to business (and as it is a bad wind which blows nobody any good) the*

# Land of the Kuskawaroaks

*hard weather had frozen the marshes and the head of* [Assawoman] *Bay over so hard that it bore us to walk over on the ice and we continued our course about a mile and a half. This was the first day in which we were able to walk on the ice since we came down and indeed the first in which we went on any ways successfully with our business. With our success we were much delighted.*

Watson and the other surveyors made their way westward, and on January 11 they reached the edge of the Great Cypress Swamp. On the next day, the weather was a little warmer; and the hard ice that had enabled the surveyors to move across the marshy terrain began to melt. Watson noted in his journal:

*The ice rotten, the water deep, thick with hollies, maples, sweet gums and low brush hung full of green briers which renders the crossing it not only impracticable but next to impossible at this season of the year, unless in time of extreme frost.*

The difficult conditions convinced Watson and the others to suspend surveying operations until September, when the swamp would be drier. When warm weather returned, Watson and the others continued to lay out the boundary between Delaware and Maryland. As they worked, they marked the border with a series of stones, incised with the coat of arms of the Penns on the north side and the coat of arms of the Calverts on the south side.

After working on the border between Sussex County and Maryland, Watson continued surveying for another decade. Watson had survived the "ice rotten and water deep" of southern Delaware; however, in June 1761, he caught a cold while surveying in wilds of Pennsylvania. After riding sixty miles to get medical attention, Watson's condition deteriorated quickly and he died shortly afterward.

After another legal dispute suspended the work of marking the borders of Delaware for several years, Charles Mason and Jeremiah Dixon were hired to finish the work that had begun in 1750. In 1764, Mason and Dixon accepted the work that had been done by the earlier survey team. In addition to the border between Maryland and Delaware, Mason and Dixon also surveyed the border between Maryland and Pennsylvania. When Pennsylvania abolished slavery, the border between Maryland and Pennsylvania became the nominal boundary between the North and the South, and the names of these two surveyors remain famous in American history. On the other hand,

the forgotten work of surveyor John Watson is marked by a small stone that sits in the shadow of the Fenwick Island Lighthouse. The stone tilts a little to one side, almost as a reminder of the many days that Watson walked, bent by the wind, across the soggy terrain of southern Delaware.

With the fracas over who owned what in southern Delaware apparently over, a slow stream of colonists began to settle within walking distance of Bethany Beach. Maryland's failed claim to the White's Creek area, however, was acknowledged when the locale was designated "Baltimore Hundred." The first Europeans who followed Matthew Scarborough cleared patches of the forest and planted tobacco. After the leaves were harvested and cured, they were packed into large casks, called hogsheads, and rolled to landings on White's Creek and other tributaries of the Indian River for shipment to distant markets. During these early years, most long-distance travel was by water; and it took many years for the narrow trail that the Nanticokes used to travel to their summer residences near the beach to evolve into a road.

## Murder on the Border

Although the southern border of Delaware had been surveyed and marked, there were still some who refused to acknowledge that the area from the Indian River Inlet south to Fenwick Island was not part of Maryland. The survey stones set by Watson and others were sometimes lost or ignored in the marshes and woods south of the Indian River. Although the border may have been clear on maps, it was sometimes difficult to tell whether a particular homestead was in Maryland or Delaware, and some settlers took advantage of the situation to avoid paying taxes to either colony. A few years after the surveyors had begun to mark the boundary, several colonists claimed to be living in Sussex County, but officials in Worcester County, Maryland, were convinced that the settlers were living on Maryland territory. These disputes were far from academic; at times, they were deadly.

In 1759, the justices of Sussex County wrote to the governor of Delaware:

> *A very unhappy and much to be lamented transaction hath lately fallen out with respect to the boundary or dividing line between this county of Sussex on Delaware and Worceter County in the province of Maryland.*

In February 1759, subsheriff William Outten and a small posse were dispatched to the home of James Willey to arrest the colonist for failure to

pay Maryland taxes. Willey was visibly angry when he reached his home; when he entered the house, Willey beat a hasty retreat to the building's loft, where he prepared to defend himself using a long pole.

Seeing Willey's pole, Outten picked up a plank and attempted to use it to force Willey out of the loft. As the two men fought, a swift stroke by Willey knocked the plank out of the sheriff's hand, and as it fell, the plank hit Willey's wife in the head. Undeterred by this setback, Outten called out to Willey, "Come down. I will take you dead or alive!"

Before Willey could answer, the sheriff heard a voice from outside, and he drew his sword and left the house to investigate. When Outten stepped outside, the sheriff was attacked by John Sharp, one of Willey's neighbors, who hit Outten with a hickory stick. As the two men tussled, Outten's sword cut Sharp's wooden stick in half, and the sheriff sliced him in the right shoulder. Willey slipped down from the loft. By this time, several other of Willey's neighbors had arrived. One called out, "Where is the damned eternal sheriff? I'll cleave him to the earth."

At this point one, of Willey's neighbors hit the sheriff with an iron bar, and the stunned Outten fell to the ground. After members of Outten's posse helped the wounded sheriff to his feet, the Marylanders began to make their way to a small building, where they had hitched their horses. As Outten made his way around the small outbuilding, Willey called out to the increasingly belligerent mob of neighbors: "Give me a gun!"

Someone handed a musket to Willey, who ran after Outten. When the subsheriff turned and faced his armed pursuer, one of the bystanders called out, "Shoot the dammed son of a bitch!" Others urged Willey to stop and put up the gun. Willey hesitated for a moment and then pulled the trigger. The blast ripped into Outten's stomach, and he died within five minutes.

Willey and his cohorts quickly decided a course of action. They called out that a coroner from Sussex County should be called to examine Outten's body, and they retreated to Lewes, where they would claim that they were peacefully living in southern Delaware when they were confronted by the Maryland posse.

At Lewes, the Sussex County Court took depositions from many of the participants in the incident. In addition, it took testimony from several people in an effort to establish the location of Willey's house. The Delaware court concluded that the incident had happened in Maryland; Willey was turned over to the Worcester County officials, who reluctantly abandoned their claim to the land on which Bethany Beach and the coastal towns now stand.

## Chapter 2
# REVOLUTION TO RESCUE

### SALT OF THE SEA

By the early eighteenth century, families who would influence the development of the Bethany Beach area for generations had settled in the region south of the Indian River. Matthew Scarborough's Middlesex tract passed into the hands of the Hazzard family and from them into the possession of the Hall family, who would become the founders of Ocean View. Most of the early families saw little value in the land that bordered the surf. The sandy soil and salty air was not conducive to growing tobacco, corn or other crops. While settlers eagerly snapped up land on the mainland and turned the forests into farms, the beaches remained a natural stretch of undisturbed dunes. The beach at Bethany may have been ignored for another hundred years had it not been for pigs.

The European colonists brought with them a menagerie of cows, horses, goats, dogs, cats and other animals, but none was more important than the pig. The swine that the settlers introduced to the coastal region were not the chubby pink pigs found on modern hog farms. The colonial pig was a tough, smart animal that foraged for its own food, avoided predators and reproduced often. A few pigs left to wander the area around the early settlements could be counted on to multiply and provide a steady supply of food for the colonists. Some Sussex County settlers kept as much as 150 pounds of ham and bacon on hand to supply their dinner table. The colonists roasted, broiled and boiled their pork, and they consumed every part of the animal. In addition to the usual cuts of meat, the head, liver, tongue and

ears graced the tables of the well-to-do, and the chitterlings were given to the servants. Scraps were turned into sausage that was considered a dinner dish.

Pigs were slaughtered in the fall when they were the fattest, and in the days before refrigerators, the meat was treated in a variety of ways to prevent spoilage. Much of the ham was cured and smoked, but another method involved a heavy dose of salt. After the animal was slaughtered, the meat was cut into manageable pieces, covered with salt and packed into large casks. Salted meat was the cornerstone of a sailor's diet, and when there was a supply of salt available, it was also used to preserve meat onshore. The need for salt goaded some hearty souls to pack their kettles and pots and head for the Delaware beaches.

When the salt-makers arrived along the Delaware coast, they sought out ponds near the beach. The ocean is less than 3 percent salt, but some ponds nestled in the dunes can be three times as salty. Before Bethany was established, the beach in the area was still in a relatively natural state. In the late nineteenth century, the historian Francis Vincent reported:

> *Fresh Pond and Salt Pond are the names of two remarkable ponds in Baltimore Hundred, situated on the Atlantic coast, a few miles south of Indian River Bay. Fresh Pond is about a half mile long by one or two hundred yards wide, and about twenty-five or thirty feet deep. It has no outlet, and apparently no streams flowing into it. It contains fresh water, and a few fish. The ridge of sand between it and the Atlantic is not more than an eight of a mile wide. Great Storms sometimes wash away a portion of this ridge, and let the salt water into the pond. But the ocean again forms the ridge and restores things to the condition they were in before.*

According to Vincent:

> *Salt Pond is another body of water about the size of Fresh Pond, and situated about three miles to the south of it. It is probably one-half of a mile further from the ocean than Fresh Pond, and the Atlantic does not break through its banks and encroach on its waters, as in the case of Fresh Pond. It, like Fresh Pond, has no outlet. Its waters are very salt[y], far more so than those of the ocean from which it is it is separated by such a slight barrier. Indeed, it is so salt[y] that no fish can live in it. Salt works were once erected on it banks, and a great deal of salt extracted from it. Salt is still manufactured from its waters by the citizens of the neighborhood for their own use.*

# Revolution to Rescue

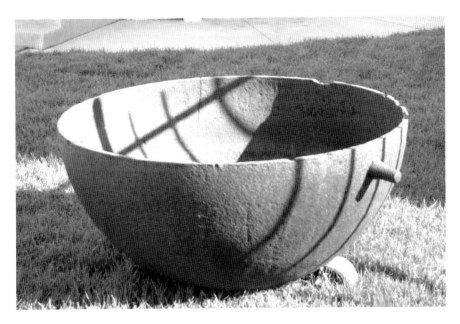

One of the large iron kettles used by salt-makers. *Photo by Michael Morgan.*

In addition to Salt Pond, there were a number of smaller pools of water near the dunes that attracted salt-makers. James and Jacob Brasure were among the first to establish a saltworks along the coast. They hauled an assortment of bricks, baskets, axes and several large stirring paddles to the beach. In addition, they brought with them large iron kettles that were about four feet in diameter. Once on the beach, the kettles were set up on a temporary hearth formed by the bricks, a fire was started and the evaporation process began.

James M. Tunnell Jr. described the salt-making activities of one of his ancestors:

> *Jehu Bennett, my great-great-grandfather, used to say that, at least some of the time, he sent the salt that he made at Bethany Beach to Philadelphia, by ox cart. Since the normal mode of transportation of salt, as well as other freight, from there to Philadelphia, was by vessel, if you did not consider the difficulty with shipping in the War of 1812 and the huge premium then paid for salt, you could not otherwise understand why loads of salt would be drawn by oxen from Baltimore Hundred to Philadelphia.*

Salt was important to residents of Baltimore Hundred, and it was vital to American success in winning the Revolution. After the Battle of Lexington

and Concord, Caesar Rodney, one of Delaware's leading Patriots, urged the Continental Army to protect the saltworks along the Delaware coast, which he considered "not only necessary but convenient for the support of our army." One of the saltworks was a small venture operated by Peter White along the beach south of the Indian River Inlet. Like most of the saltworks on the Delaware coast, White's operation was a temporary affair, and it produced only 170 bushels of salt before it was discontinued.

In February 1777, the Delaware House of Assembly authorized

> *the sum of £1,000 be let by this state upon loan to the said Col. John Jones (the better to enable him to carry into execution his intention of erecting salt works in this state, at or near Indian River, in Sussex County).*

Not only did the state lend Jones the money to establish his saltworks on the Delaware coast, but the legislature also agreed to "purchase or take of him the quantity of 10,000 bushels of salt, at the rate of five shillings per bushel, annually for the space or term of five years."

Even with solid financing from the state and guaranteed sales for five years, salt-making along the coast had its hazards. The salt-makers had to pay special attention to any vessels that sailed by that were flying a British flag. Although the British ships usually sailed by without incident, the salt-makers could not be too cautious. They might be spotted by a perceptive English captain who had noticed the activity on the barren dunes and reported to one of the British warships that patrolled the coast. It would not be difficult for an attentive naval officer to launch a small boat filled with armed men to investigate what the Americans were doing.

Colonel Jones, armed with a lucrative government contract, had a golden opportunity to establish a major saltworks along the southern Delaware coast, but during the next two years, he had failed to produce a single grain of salt. Coastal entrepreneurs, however, filled the void created by the failure of Jones to live up to his contract and established a number of small salt-making ventures that operated intermittently into the nineteenth century.

## Fugitive by the Ocean

Fortunately for John F. Smyth, when he reached the Delaware coast, there were no salt-makers in sight. He found nothing but barren dunes. When Smyth arrived on the coast, the beach from Indian River Inlet to the

Maryland line was an unbroken ribbon of sand. When Smyth saw that there was no one on the beach to greet him, he was pleased. On the other hand, when Smyth saw that not a single ship was visible on the ocean, he was deeply disappointed.

When Smyth arrived in southern Delaware during the American Revolution, the residents of southern Delaware were deeply divided between the Patriots, who wanted to separate from Great Britain, and the Tories, who remained loyal to England. Smyth was a Tory who had been captured by the Patriots and imprisoned in Baltimore; but in January 1777, Smyth, Thomas Slater (a Loyalist from Maryland) and Thomas Robinson and Boaz Manlove, two prominent Sussex County Loyalists, made their way along the southern shore of the Indian River to the beach. The small band of Tories knew that the British frigate *Roebuck* had been in coastal waters for several months, and Smyth hoped to find refuge aboard the British warship. When the small group of Loyalists reached the beach near the Indian River Inlet, however, it discovered that the *Roebuck* had left the coastal region a week earlier.

The day after they arrived on the coast, however, Smyth and his party spotted the small British sloop of war *Falcon*, which was anchored near Indian River Inlet. The Tories had found a small boat, and Slater was dispatched to make contact with the British ship. "We are British prisoners," Thomas Slater pleaded with Captain Linzee of the *Falcon* as the English warship lay off the Indian River Inlet, "who have escaped at the certain hazard of our lives from long and most cruel confinement. Two of the men with us are first gentlemen of property and interest in the county and they are extremely anxious to get on board. They have been driven from their homes to avoid the persecution of the rebels."

Linzee carefully considered Slater's request to send a small boat to the Sussex shore to rescue the small band of Tories who were hiding from the American Patriots. He had landed some American prisoners whom he did not have room for on his small vessel, and he had burned an American schooner near the mouth of the Indian River Inlet. These actions had surely alerted the Patriots of Sussex County to the presence of the *Falcon*. In January 1777, the Delaware coast was a dangerous place for British sailors to be caught ashore. Linzee told Slater that he could not chance sending a small boat ashore. The dejected Tory climbed into his small canoe and reluctantly rowed to the Delaware beach.

After Slater reached shore, he told the small band of Tories the bad news. The British captain refused to rescue them. As one of the Tories later recalled:

> *This was inexpressibly discouraging to all the friends to government; and one of the most truly mortifying disappointments to us that we could possibly have experienced.* [The] *Next morning we viewed the ocean with many a longing earnest look, still flattering ourselves with hope that the ship might return, but all in vain.*

After Captain Linzee refused to pick them up, the Tories spent another month and a half hiding in the coastal dunes and marshes as they watched in vain for the appearance of a British ship. Despairing that they would not be picked up, the Tories retreated inland, where they discovered that many residents of southern Delaware were British sympathizers. Smyth later recalled:

> *I am confident that there was not one of them but would have cheerfully lost the last drop of his blood for the King, and the British government. The principal gentlemen of the country for sixty or eighty miles around came constantly to us, in the dead of night, in order to assist us, and to furnish us with all the intelligence of the country. They acquainted me with the very favorable disposition of a great majority of the inhabitants to his Majesty's government, and requested my directions for their future conduct.*

Although there were many who were willing to aid the Loyalists, there were just as many Patriots who would have gladly helped capture them. Smyth, Robinson and the others never remained in the same hiding place for more than three days in a row; when they moved to another location, they did so at night.

While he was hiding in southern Delaware, Smyth always carried a musket, a supply of ammunition, a pair of pistols and a sword. He later declared:

> *As from what I had already experienced, I infinitely preferred death to captivity. I was most resolutely determined to defend myself to the last extremity, even if 500 men should attack me, for they should never have taken me alive.*

Smyth never had a chance to use his weapons, but one night the Tories were awakened by the arrival of riders. According to Smyth:

> *The master of the house wherein we were concealed awakened us about midnight, and informed us that we should all be taken for we were*

> *surrounded with the enemy, and by the moon-light we could plainly perceive that a formidable number of men had actually encompassed the house; we immediately prepared for defense, and were leveling our pieces against them, when Mr. Manlove distinguished one of them as his brother.*

The riders brought news of the movements of the Patriots. After a spring thaw melted the winter snow that had made it easy for the Patriots to track them, the Tories decided that it was time to leave Sussex County.

During two months of hiding along the southern Delaware coast, no British vessels ventured close enough for the Tories to signal. Throughout the colonial period, the residents of the south shore of the Indian River had used shallow-draft vessels to sail through the Indian River Inlet to Philadelphia, New York and other ports. While the Tories vainly watched for British ships, an American vessel would occasionally slip into the inlet to a convenient landing, where the powder, musket balls and other munitions would be loaded on wagons and hauled overland to Chestertown, Maryland. From there, the war supplies would be shipped to General George Washington's Continental Army.

Smyth, who "infinitely preferred death to captivity," decided that the Tory band needed to leave the Indian River area and travel up the coast to Cape Henlopen. Smyth knew that there were several British ships that patrolled the mouth of Delaware Bay, but he also knew that there were a large number of American Patriots at Lewes. Nonetheless, Smyth and ten other Loyalists procured a primitive boat (which may have been an old Nanticoke canoe) and headed northward.

Smyth later wrote:

> *Our canoe was formed out of the trunk of a single tree hollowed or dug out, and we depended solely upon oars, as these kind of vessels are best very dangerous and never carry a sail…When we came to the mouth of Indian River, there was a dangerous bar to cross, and the breakers or waves were running prodigiously high.*

After passing through the Indian River Inlet, the Tory band paddled northward through the ocean to Cape Henlopen. Once the band reached the cape, the Loyalists headed into Delaware Bay, where the British ship *Preston* lay at anchor in a thick fog. As Smyth and his party tried to see through the fog, the large, dark shape of a ship loomed before the exhausted men. At first, the Tories were afraid that the vessel might be an American

ship, but Smyth spotted the name "Preston" on the ship's stern, and he knew that it was a British ship. This time, the captain eagerly took the fugitive Tories aboard, and their escape from "long and most cruel confinement" had ended.

## Tragedy of the *Faithful Steward*

In 1785, peace had been made with Great Britain, and the United States had been established as an independent country, but the Delaware coast from Bethany Beach northward past the Indian River Inlet remained a desolate place. With American independence, the flow of immigrants that had been interrupted by the war was renewed. In July 1785, more than two hundred immigrants boarded the *Faithful Steward* in Londonderry, Ireland, for the voyage to America and a new life. Among the passengers were several extended families that included grandparents, parents, children and small babies. The four dozen members of the Lee family were the largest group of relatives aboard the ship, but there were also several members of the Elliott and Espey families on the *Faithful Steward*.

More than a decade before the *Faithful Steward* sailed from Ireland, William Espey had immigrated to America. When the American Revolution began, he enlisted in the Continental Army. During the war, Espey was part of General George Washington's brave band of soldiers who crossed the Delaware River on Christmas Day 1776 and dealt the British a stunning defeat at the Battle of Trenton. Espey continued to serve until the British were defeated at Yorktown; after the war, he received a grant of land in the Youghiogheny Valley in western Pennsylvania, where he settled down to the tranquil life of a farmer. In July 1785, Espey's parents and three of their youngest children began the long voyage to America aboard the *Faithful Steward* to join William.

Few details of the *Faithful Steward* have survived, but it is probable that it was a square-rigged, three-masted ship. In July 1785, the ship sailed under the command of Connally McCausland, an experienced captain, from Ireland bound for Philadelphia. According to the *Maryland Gazette*, "On the 9th day of July last, said vessel sailed from Londonderry, having on board 249 passengers of respectability, who had with them property to a very considerable amount."

By the late eighteenth century, sailing from Europe to America had become routine since Christopher Columbus first crossed the Atlantic in 1492; when

McCausland set sail from Ireland, the *Faithful Steward* was just one the latest of countless ships that followed in the wake of the *Niña, Pinta* and *Santa Maria*. In addition, McCausland employed navigation techniques to guide the *Faithful Steward* that were closely related to those used by Columbus.

During the age of sail, McCausland and other captains had only the sun, moon and stars to guide them. A competent navigator could determine his latitude, but only a highly skilled and lucky mariner could accurately plot his longitude. When McCausland determined that the *Faithful Steward* was at the latitude of the Delaware coast, all he needed to do was to continue westward until he made landfall, turn north and look for Cape Henlopen and the entrance to Delaware Bay. Although accurate clocks that could help determine longitude had been invented, it is not known if McCausland had one aboard the *Faithful Steward*, and his inability to correctly calculate his longitude proved disastrous.

According to the *Maryland Gazette*, "They had had a favorable passage, during which nothing of moment occurred. The greatest harmony having prevailed among them." Having reached the Delaware coast, McCausland had only to locate the distinctive lighthouse at Cape Henlopen and sail safely into Delaware Bay. When the *Faithful Steward* arrived off the coast, however, McCausland was not looking for the cape—he did not realize how close he was to the shore. McCausland's imperfect calculation of his longitude led him to believe that the *Faithful Steward* was still a comfortable distance from the Delaware coast.

As a prudent navigator, however, he decided to sound for the bottom; when he did, he was shocked by the results. The *Maryland Gazette* reported:

> [On] *the night of Thursday, the 1$^{st}$ instant, September, when at the hour of 10 o'clock it was thought advisable to try for soundings and to their great surprise found themselves in four fathoms water, though at dark there was not the smallest appearance of land.*

The *Faithful Steward* was in only twenty-four feet of water, which McCausland knew meant that the ship was well onto the continental shelf; if he continued westward as the winds were blowing him, his ship would soon be on the beach.

The results of the soundings reached the crew, and the reaction was predictable. There was consternation aboard the ship as the crew made every effort to reverse course and get the ship away from the beach. Unfortunately, for McCausland and those aboard the *Faithful Steward*, a sailing ship cannot

easily reverse direction while sailing with the wind. The ship had crossed the point of no return. There was little that could be done to extradite the ship from disaster; the shutter of the vessel grinding to a halt as the keel dug into the bottom was a sensation feared by all sailors. Floating free, a ship can withstand most waves; but held firmly in one place, waves will pound loose the ship's seams and splinter the vessel's planks. It was only a matter of time before the ship would be destroyed by the sea. McCausland and the crew knew that the only way to save the *Faithful Steward* was to lighten the ship so that the hull's buoyancy would lift it free of the sandbar. With a zeal of men facing death, the crew attacked the ship's masts and rigging with axes.

This desperate effort failed, and as the ship sat on the sandbar, the *Faithful Steward* was spotted by those onshore. At that time, there were no permanent residents on this part of the Delaware coast, but beachcombers regularly walked the sand and watched for vessels in distress.

Some accounts of the disaster suggest that those who gathered on the beach came only to snatch any valuables that might wash ashore. The *Maryland Gazette*, however, reported otherwise:

> *During the course of the day, the inhabitants came down to the beach in numbers, and used every means in their power to relieve the unfortunate people on board.*

As they watched from the beach, those onshore could hear the cries and pleas for help from those aboard the *Faithful Steward*—which was only one hundred yards from the beach—but there was little that they could do. Aboard the ship, McCausland and the crew attempted to launch the ship's boats, which were picked up by the waves before they could be loaded with passengers.

McCausland, several members of the crew and some of the passengers were able to reach shore, but they were unable to return to the stranded ship. The tragedy of the *Faithful Steward* now entered its final act. Those left aboard the ship, families who had hoped to make a new start in America, were in a hopeless position. The timbers were groaning and cracking under the hammer blows of the waves. Water cascaded through openings ripped in the vessel's hull. Some resigned themselves to their fate; others plunged into the surf in a desperate attempt to reach shore. One passenger reputedly offered a member of the Elliott family a sack of gold if he wanted to save it. The man refused, and unencumbered by the gold, he was able to swim ashore.

With the ship breaking apart, some of the passengers attempted to swim ashore, and a mother and father worked feverishly to save their two children. As the waves pounded the *Faithful Steward*, the parents tied a piece of a spar across the chest of their teenage daughter and quickly strapped their baby son on her back. The two were cast into the sea with the hope that the strong westerly winds would carry the two children through the surf to the beach.

The *Maryland Gazette* recounted the grim finale of the *Faithful Steward*:

> *All relief was cut off, except by swimming or getting on shore on pieces of the wreck, and we are sorry to add, that of the above, only 68 persons were saved, among which were the master, his mates and 10 seamen.*

Of the one hundred women and children aboard the ship, only seven were saved. Of the four dozen members of the Lee family on the ship, only six survived. Also among the dead were William Espey's parents. His sister, Mary, made it ashore alive, but she died the next day. Two brothers, James and John, survived the disaster, but James was so severely injured that he was crippled for the rest of his life.

The wreck of the *Faithful Steward* on September 1, 1785, was the greatest disaster to have occurred on the Delaware coast. With nearly two hundred people killed in the shipwreck, the beach was littered with the bodies of the dead. The coastal residents collected the corpses and buried them in several mass graves. In addition to the human tragedy, the ship was carrying a cargo of coins that was dumped into the sea by the storm. The coins were scattered by the waves, but every so often, one is discovered by an alert beachcomber walking the sands near the Indian River Inlet.

## A Dab of Color on the Beach

In the years following the *Faithful Steward* disaster, the population of the coastal region continued to grow. Although there still was little interest in the beach, the high ground near the head of White's Creek continued to attract enterprising families. In addition to farming, some of the residents of the area established sawmills and harvested the lumber of the region's forests. Others began a thriving boat-building industry to construct small flat-bottomed sailing vessels that could navigate the shallow water of the Indian River Inlet.

At the beginning of the nineteenth century, W.S. Hall operated a store on his farm near White's Creek, and the area became known as "Hall's

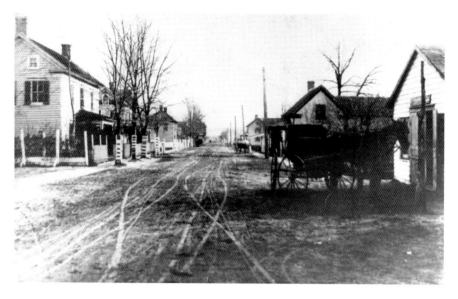

Ocean View before cars clogged the streets. *Courtesy of the Delaware Public Archives.*

Store." A post office was established there in 1822, and soon Hall's Store had developed into a thriving village. After the Civil War, the town was renamed Ocean View—because, so the story goes, you could see the ocean from the second floor of some of the town's houses. At that time, the coastal area attracted many sportsmen. A guidebook for hunters and fishermen that was published shortly after the town's name was changed commented:

> *Ocean View, on one of the arms of the Indian River, is also in high repute with gunners and anglers. It is reached by livery from Frankford, about twelve miles distant. A hotel is kept open there during the summer; rate, one dollar and a half per day. Boatmen and boats at very moderate charge.*

Those sportsmen who stayed at Ocean View and took the time to get a glimpse of the beach saw a long stretch of dreary dunes relieved only by the colorful lifesaving station that was built just north of the inlet.

Following the Civil War, the United States Life-Saving Service was reorganized, expanded and established on a professional basis. The service began an aggressive construction program, and in 1876, an isolated site just north of the Indian River Inlet was selected for a new station. The new Delaware facility was considered a first-class station that was manned by professional surfmen who were recruited from the surrounding area but who

# Revolution to Rescue

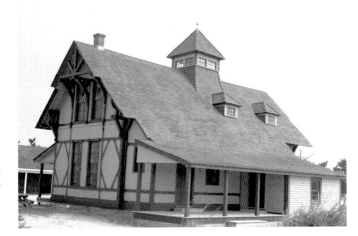

The Indian River Inlet Life-Saving Station has been standing guard on the coast for more than a century. *Photo by Michael Morgan.*

lived at the station while they were on duty during the active season, which extended from the fall through the winter into spring.

Once the surfmen had arrived for the season, the duties of cooking, cleaning and other housekeeping chores were assigned to each man on a rotating basis. The surfmen slept on simple cots arranged dormitory-style in a single small room. A larger mess room served as a common area where they ate, relaxed and read from a small library. Few decorations adorned the walls of these rooms, to reflect the serious mission of the lifesaving station. The keeper, who commanded the station, had his own room and office, but these areas were far from luxurious. The largest room in the station was reserved for the surfboat, Lyle gun and other equipment.

The surfboat was mounted on large wheels so that it could easily be rolled across the sand. After the surfmen reached a point on the beach near a stranded ship, they would slide the boat off its wheels so that they could launch it through the breakers. Rowing a surfboat through the breakers required strength, skill and coordination by all members of the lifesaving crew. Each surfman manned an oar; as they pulled together, the keeper steered the surfboat directly at the waves.

In addition to being skilled with the surfboat, the crew of the Indian River Life-Saving station had to be proficient in handling the Lyle gun, which was used to fire a line to a ship in distress. Once the line had been secured and fully rigged, breeches buoys and surf cars could be used to ferry those in distress ashore.

Once it was finished, the Indian River Inlet Life-Saving Station brought assurance to those sailing along the Delaware coast that someone was always

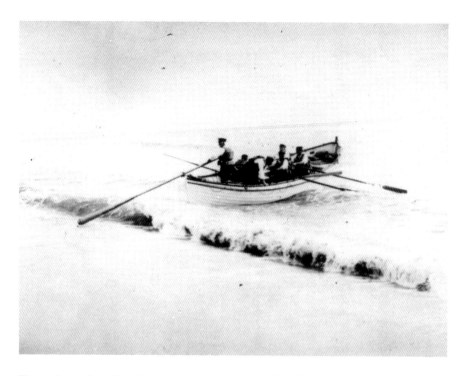

The surfmen of the lifesaving station were experts at riding through the surf. *Courtesy of the Town of Bethany Beach.*

on alert for a ship in distress. In addition, the station, with its pumpkin-colored walls and burgundy roof, brought a dab of much-needed color to the beach.

## Leader *Par Excellence*

In March 1888, the White Hurricane, one of the worst winter storms to visit Delaware, was pounding the coast. According to a contemporary account of the storm:

> *The terrible tempest of wind and snow that swept over a large portion of the United States on March 12, 1888, will not soon be forgotten…The sleet and snow blew in straight streaks through the air and mounted into tremendous drifts wherever obstructed…Travel was suspended, all means of communication were cut off, and the ordinary pursuits of life in the great*

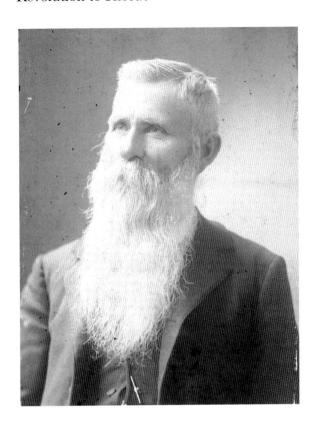

Washington Vickers was a leader *par excellence*. Courtesy of the Indian River Inlet Life-Saving Museum.

*cities, towns, and hamlets were brought, with startling abruptness, to a complete stand-still. Desolation and suffering were marked on every hand. Many lives were lost, and doubtless hundreds more were shortened.*

With no ship in distress in sight and despite the brutal weather conditions, Keeper Washington Vickers ordered the surfmen of the Indian River Life-Saving Station out into the storm.

With the wind, snow and ice pounding the Delaware coast, Vickers knew that vessels at the mouth of the bay would be in trouble. Leaving half of his surfmen at Indian River, he and two other crewmen left the comfort of the station and began to battle their way through the wind and snow toward Cape Henlopen.

Several hours later, after Vickers had completed his icy trek across fourteen miles of frozen dunes, he discovered the crews of the Lewes and Cape Henlopen Life-Saving Stations struggling to rescue scores of sailors from storm-damaged ships huddled behind the Delaware Breakwater. In

particular, Vickers spotted a boat filled with sailors and surfmen that was in danger of sinking into the icy waters. According to the official report of the incident:

> *Taking in at a glance the peril of their comrades, they hurried to the marine hospital, where they knew a number of sailors were quartered, and, quickly mustering a force of strong men, hastened back to the shore. The beach party then hauled with a will on the whip-line* [which was attached to the boat]…*Finally, it was brought to land, though not before one of the surfmen had been prostrated by the cold and several others frost-bitten. All hands were immediately taken to the hospital, where they were kindly cared for, the physician in charge having had warm coffee and food prepared for them. In all likelihood, the men in the boat would have perished had not the surfmen from Indian River Inlet put in an appearance when they did.*

The quick and heroic action by Vickers during the White Hurricane of 1888 was typical of a man whose character had been tempered in battle and who had devoted much of his life to serving others. Vickers was born in Seaford in 1842, when the simmering divisions between the North and the South had begun to divide the residents of southern Delaware. Two decades later, these divisions boiled over into civil war. A number of prominent men from Sussex County sympathized with the South, but quick action by the Union forces ended most organized efforts in southern Delaware to assist the Confederacy. Young men who wished to join the Northern army could enlist in a Delaware regiment at a Georgetown recruiting station, but those who wanted to fight for the Confederacy slipped quietly out of Delaware to join units of the Southern army that were organized in other states.

In 1862, Vickers left Sussex County and enlisted in the Second Maryland Regiment of Robert E. Lee's Army of Northern Virginia. A year later, Vickers was part of the Confederate army that Lee hurled against Major General George Meade's Army of the Potomac at Gettysburg. On the second day of the battle, Vickers and the Second Maryland attacked the right flank of the Union army on Culp's Hill; during the fighting, nearly half of the regiment's soldiers were killed or wounded. One of the wounded was Vickers.

After Lee was defeated at Gettysburg, the Confederate army retreated to Virginia, and Vickers was sent to Chimborazo Hospital in Richmond to recover from his wounds. Chimborazo's three thousand beds made it one of the largest military hospitals in existence; Vickers remained there for nearly

a year. By April 1864, he had recovered from his injuries, but he remained at Chimborazo as a nurse. Vickers served as a nurse for the rest of the war.

When the U.S. Life-Saving Service was created after the Civil War, Vickers enlisted as a surfman at Hog Island, Virginia. After one season at Hog Island, he transferred to the station on Assateague Island, where he remained for several years. In 1882, Vickers returned to Delaware and moved to the Indian River Life-Saving Station, at which he was promoted to keeper in 1886.

Writing in the *Organization and Methods of the United States Life-Saving Service*, Sumner Kimball, the general superintendent of the service, declared that the keepers

> *are the captains of their crews; exercise absolute control over them (subject only to the restrictions of the regulations of the Service and the orders of superior officers); lead them and share their perils on all occasions of rescue, taking always the steering oar when the boats are used, and directing all operations with the apparatus.*

Kimball also noted:

> *In the vicinity of nearly all the stations there are numbers of fishermen and wreckers who have followed their sailings from boyhood and become expert in the handling in broken water, among them there is usually some one who, by common consent, is recognized as a leader par excellence. He is the man it is desirable to obtain for keeper, unless there be some fault of character which should exclude him.*

## GAMBLE OF THE *RED WING*

When the crew of the fishing schooner *Red Wing* lifted anchor and sailed from behind the protective barrier of the Delaware Breakwater, a strong nor'easter was boiling up the coast. In the late nineteenth century, the *Red Wing* was somewhat of an antique. Unlike more modern steam-driven vessels, the *Red Wing* was powered only by the wind; John Johnson, the master of the schooner, needed to read changes in the weather carefully to keep his vessel safe. Should he encounter any difficulty, Johnson and his Swedish crew could take comfort in the line of lifesaving stations on the Delaware coast that stood ready to offer assistance. On October 21, 1891,

however, Johnson would be confronted by a storm that would test every ounce of his seafaring experience.

After the *Red Wing* cleared Cape Henlopen, Johnson headed for the fishing banks near the mouth of the bay. While the men worked the waters for bluefish, the wind began to rise as the nor'easter rolled up the coast. When the first northeasterly breeze began to buffet the small schooner, Johnson was unconcerned. A strong wind had begun to blow out of the northeast, but the crew of the *Red Wing* continued to work the waters in search of bluefish. About three o'clock in the afternoon, the wind shifted to the north-northwest, the weather turned cold and the waves began to build; Johnson and his crew seemed to be weathering the storm without difficulty. As the gale increased, the schooner was forced southward, and Johnson was unable to tack around Cape Henlopen to the reach the breakwater. When darkness began to envelop the struggling schooner, Johnson decided that his only course was to place himself, his crew and his vessel at the mercy of the wind. Instead of heading back into the Delaware Bay and the protection of the breakwater, Johnson decided to head south.

He ordered the crew to reef the mainsail; with only few stretches of canvas aloft, the *Red Wing* started a mad dash southward. Driven by the wind, he skimmed his way down the coast. This maneuver left him with little control of his vessel, and he was gambling that the schooner would reach the outer edge of the storm before the *Red Wing* ran into some other difficulties. Unfortunately, the sandbars that lined the Delaware coast lay ahead.

About sunset, the wind had become a northerly gale, and the crew of the *Red Wing* was busy taking in the schooner's mainsail as it ran past the Cape Henlopen Life-Saving Station. A few minutes later, a surfman from the Rehoboth Beach Life-Saving Station spotted the *Red Wing* sailing close to the beach. Fifteen minutes later, a surfman on the north patrol from the Indian River Life-Saving Station spotted the *Red Wing* being driven down the coast by the relentless gale. He also lit a flare to warn the *Red Wing* away from the beach, but the vessel continued on its perilous course.

The *Red Wing* sped past the Indian River Life-Saving Station, but Johnson was unable to steer his speeding vessel into the Indian River Inlet. Perhaps he was hoping to reach the bulge in the coast at Fenwick Island, where he might find some shelter from the fierce north wind.

At 7:30 p.m., a surfman making the south patrol from the Indian River station reached the north side of the inlet. Seeing nothing out of the ordinary, he turned around and headed back to the station. By this time, the *Red Wing* was three miles south of the inlet in the vicinity of Cotton Patch Hills,

where the schooner ran aground on a sandbar. Knowing at once that the *Red Wing* was in grave danger, Captain Johnson had a distress flare ignited. On the beach, the surfman had begun to retrace his steps back toward the lifesaving station. As he turned to make his way northward, the wind drove the rain and sand into his eyes. He immediately turned around and walked backward. With his face to the south, the surfman spotted the distress flare from the *Red Wing*.

According to the *Annual Report of the Life-Saving Service*, the surfman

> *ran to a little elevation on the beach and fired his Coston signal to let the people know that they were seen, and also to alarm the station. Taking the bearings by the run of the coast, he located the light as near the Cotton Patch Hill, a notable landmark three miles south of Indian River Inlet.*

At the station, Keeper Washington was away on important business, but his well-trained crew reacted as if he were present. A rocket was sent up to recall the north patrol to the station; the crew, led by ranking surfman John H. Long, headed toward the stranded vessel. The storm had turned the beach into a series of deep gullies and ruts that made it impossible to roll the surfboat to the inlet. Long immediately had the lifesaving equipment placed into the boat, which he launched into the bay waters. According to the official report of the incident:

> *To do this in the face of the gale and flying sand and rain was a hard and tedious task, as the storm tide was up over the meadows and covered the little drains that abound in the mashes which fringe the shores of the bay…The water also was flying over the boat in such volume as to necessitate constant bailing, and as much precious time was fleeting away it was decided to pull directly across the inlet, land wherever they could, and endeavor to cross the marsh and go down to the beach that way.*

Aboard the *Red Wing*, Johnson and his crew were frantic. As the surfmen from the lifesaving station made their way southward, the crew of the *Red Wing* had become desperate. The six men aboard the vessel climbed into the rigging to escape the battering waves that were pounding the schooner. It was a death trap. The waves rolled the *Red Wing* over, flinging the men against the masts, hull and rigging. When the surfmen arrived on the scene, they discovered a dark object in the surf:

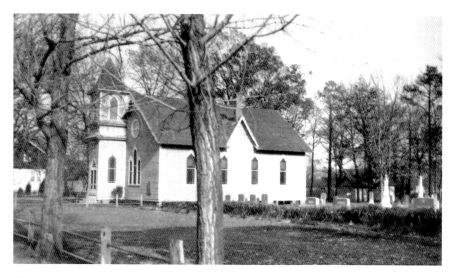

The Ocean View Presbyterian Church, where the crewmen from the *Red Wing* are buried. *Courtesy of the Ocean View Historical Society.*

> *Close examination between the seas reveled a shapeless mass of spars, rigging, sails, and timbers, evidently the wreck of a small vessel bottom up, the sails and rigging being wrapped about the hull as though she had been rolled over and over through the surf and flung bottom up with all her belongings onto the shore.*

Keeper Vickers would have been proud of the heroic struggle his surfmen of the Indian River Life-Saving Station had made to reach the wrecked schooner, but they had arrived too late. There was little that they could do but collect the lifeless corpses of the six sailors who had washed ashore. The bodies were taken to the Ocean View Presbyterian Church, where they were buried in an unmarked grave.

## Chapter 3
# BETHANY BLOSSOMS AT THE BEACH

### TABERNACLE IN THE SAND

Rehoboth Beach, like many other resort towns, started quietly in a pine grove in which religious camp meetings were held. The genesis of the resort at Fenwick Island was a number of squatters who set up their small cottages in the shadow of the lighthouse. Bethany Beach, however, began with a bang. On July 12, 1901, a band belted out the familiar notes of the stirring song "Marching Through Georgia," as a lively chorus enthusiastically sang words that had been tailored for the occasion. As the music reverberated through an unfinished eight-sided building and echoed over the Delaware dunes, Dr. F.D. Power and the other church leaders could not have been more pleased.

During the nineteenth century, Methodists and other Christian denominations sponsored revivals that featured open-air assemblies and extended camp meetings. This religious movement coincided with a growth in adult education. The Lyceum movement began in Massachusetts to encourage the development of adult education by establishing libraries and evening schools and conducting lectures. In Chautauqua County, New York, a summer training program for Sunday school teachers evolved into a traveling lecture series. The Chautauqua program became the model for a number of educational programs that were generally housed in large tents and given the generic name "Chautauqua."

In 1898, Dr. F.D. Power, a minister at the Vermont Avenue Christian Church in Washington, D.C., told a convention of the Disciples of Christ of

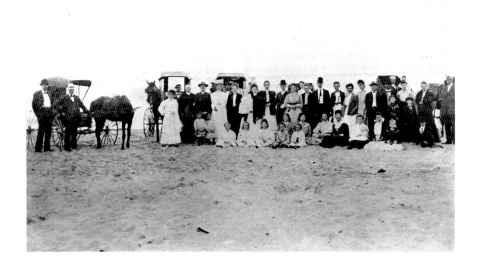

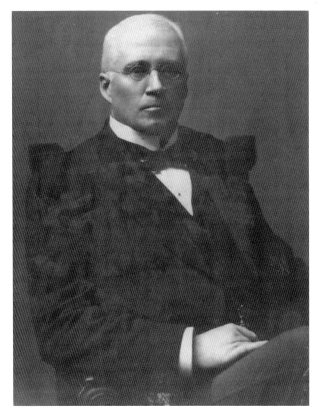

*Above*: Early visitors pause for a group picture on the beach. *Courtesy of the Delaware Public Archives.*

*Left*: Dr. F.D. Power was instrumental in establishing Bethany Beach. *Courtesy of the Town of Bethany Beach.*

## Bethany Blossoms at the Beach

his dream of establishing a Christian meeting ground on the Atlantic coast. Power foresaw a place where people could spend their summers enjoying the surf, sand, and cool sea breezes, "rejoicing in the wholesome and happy fellowship." Power wanted "a haven of rest for quiet people," where they could find a "safe and rational way of spending the heated term." In addition, the new resort would feature a large auditorium at which church services, lectures and other programs would be held. A search committee selected a spot on the Delaware coast south of the Indian River Inlet not far from Ocean View, where the mainland ran all the way to the beach.

The site that had been selected for the seaside resort was just east of area of the coast known as "Muddy Neck," which was a less-than-inspiring name for a "haven of rest for quiet people." A nationwide contest was held to select a name for the new meeting ground, with an oceanfront lot in the new development offered as a prize for the winning name. There was widespread interest in the proposed seaside meeting ground, and a committee of three men from Scranton, Pennsylvania, was appointed to sift through the entries for the most appropriate name. The committee selected "Bethany Beach" as the name of the new seaside community.

By 1900, Bethany Beach had been divided into 40- by 125-foot lots, offered for sale at prices that ranged from $75 to $200. Lots could be purchased for

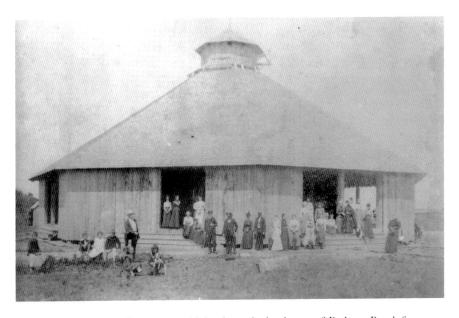

The Tabernacle, or Auditorium, would dominate the landscape of Bethany Beach for decades. *Courtesy of the Town of Bethany Beach.*

as little as $10 down with payments of only $1 per week. In addition to the residential lots, the Christian Church reserved a large area near the center of town to serve as the "Assembly Grounds," where they erected a distinctive auditorium, known as the "Tabernacle" or "the Auditorium."

The octagon-shaped wooden structure was designed with sides that could be opened to allow the sea breeze to cool the audience. Looming over an open field several blocks from the beach, the brown-shingled Tabernacle would become a symbol of Bethany for more than half a century. On Sundays, the building was used for church services; during the rest of the week, the Auditorium hosted Chautauqua lectures, political meetings, musical presentations and other events. In 1905, Power commented on the programs held in the Tabernacle that year:

> *E. Cramblet, of Bethany, and his illustrated lectures on the Holy Land. The service rendered by President Cramblet was of a high order and gave eminent satisfaction…Mrs. Princess Long come on July 21–26 with her splendid concerts and solos. Her evenings were largely attended and she received the unstinted praise which everywhere and always comes to this sweet singer in Israel. Wallace Tharp was with us the second week and that sermon "The Withered Hand" and lecture on "Babylon" will long*

Princess Long's concerts in the Auditorium were well received by the people of Bethany. *Courtesy of the Town of Bethany Beach.*

## Bethany Blossoms at the Beach

*linger in the memories of our visitors. The Doctor is not only a skillful fisher of men, but knows how to throw a line in the briny deep and play an ocean trout, or write a sonnet with equal dexterity and beauty.*

Some of the lectures held in the Tabernacle were illustrated with lantern slides. Power noted, "A.E. Zeigler, of Wheeling, made his debut at the beach as a stereopticon entertainer, and his pictures and descriptions were full of interest."

In addition to these lectures, slide shows and other entertainment, the Auditorium was used to show some of the first motion pictures at the beach. Movies as a form of mass entertainment were in their infancy, and most films were only about ten minutes long. Power, however, reported, "Nothing takes quite so well with our rural patronage and with the youngsters as the moving pictures."

# THE LONG, LONG ROAD TO BETHANY BEACH

Bethany Beach may have opened with a bang, but the resort was perched on an isolated stretch of the Delaware coast. The dirt road that followed the

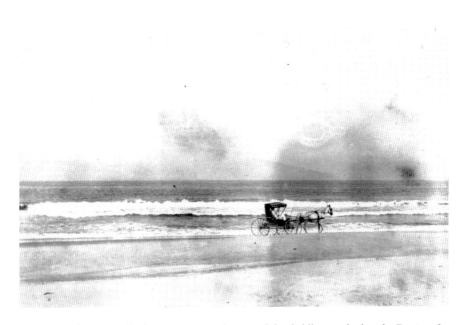

After a long journey to Bethany, some vacationers enjoined riding on the beach. *Courtesy of the Town of Bethany Beach.*

old Native American trails to the beach was bone-jarringly bumpy in dry weather and a muddy quagmire in the rain. Getting to Bethany was difficult for residents of Dagsboro, Frankfort and other southern Delaware towns; for vacationers who lived in more distant cities, reaching the new resort to enjoy the surf, sea breezes and speeches at the Tabernacle required a major expedition. Not only did vacationers come from Washington, Baltimore and Philadelphia, but Bethany also attracted many visitors from Pittsburgh, Johnstown and other midwestern cities.

In the early twentieth century, when many vacationers at Bethany came from the Pittsburgh area, they began their journey to the beach by packing an assortment of trunks and suitcases with enough clothes, hats and shoes for an extended visit. In addition to the necessities, there were also books, toys and an occasional pet. In the early days of the resort, the proportion of people who stayed for the season was very high. After the luggage was packed, many families boarded a horse and carriage for a ride to the train station. At the beginning of the twentieth century, many cities were served by electric streetcars, and the Bethany-bound vacationers may have hoisted their luggage onto a streetcar bound to a railroad station. Others began their journey by packing their luggage aboard a horse-drawn carriage to ride to the railroad station, where they boarded a train for the first leg of their trek.

The train chugged eastward out of the mountains to Baltimore, where the travelers stayed overnight. In the morning, the vacationers from Pennsylvania joined others from Washington and Baltimore in Baltimore's Inner Harbor, where they boarded a steamer. As they sailed down the Patapsco River and the steamboat reached the Chesapeake Bay, it turned south, crossed the bay and landed at Love Point on the northern tip of Kent Island.

After the two-and-a-half-hour boat ride, all of the luggage, suitcases and other paraphernalia needed for a stay at the beach was unloaded from the steamer and hoisted aboard a train for the trip across the Delmarva Peninsula. Aboard the train, passengers rode in spacious cars that featured comfortable upholstered seats. Open windows allowed for a constant flow of fresh air, which was usually peppered with cinders and ashes that spewed from the engine's smokestack. The passenger cars had no air conditioning, and train passengers had to ride with the windows opened, allowing the smoky debris to infiltrate the cars. At the end of the train ride, vacationers took a few minutes to beat the soot and ashes from their clothes.

The train ride across the Delmarva Peninsula ended at Rehoboth Beach, where the vacationers again loaded their trunks, suitcases and other bags onto a horse-drawn bus that took them to a landing on the Lewes and Rehoboth

## Bethany Blossoms at the Beach

Pennewell's Landing at Ocean View was one stop on the way to Bethany. *Courtesy of the Town of Bethany Beach.*

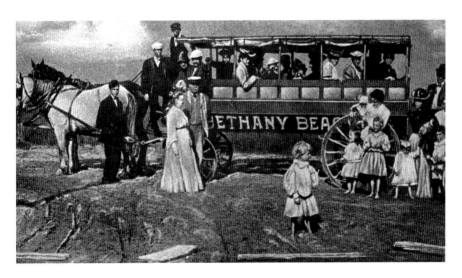

The bus carried vacationers to Bethany beach. *Courtesy of the Town of Bethany Beach.*

Canal. There they boarded a small boat for the trip southward across Rehoboth and Indian River Bays to Pennewell's Landing in Ocean View.

After the boat reached Ocean View, the luggage and vacationers were again transferred to another horse-drawn bus for the ride into Bethany

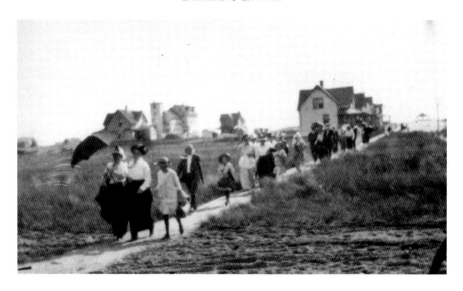

Visitors to Bethany on their way to meet the boat at the Loop Canal. *Courtesy of the Town of Bethany Beach.*

Beach. By 1910, the "Loop Canal" was dug so that boats could steam directly into the center of the resort. From the landing at the foot of First Street at Pennsylvania Avenue, vacationers made the last, short leg of their trip across the sandy streets to their accommodations for the summer.

Dr. Power did not exaggerate when he wrote of these determined visitors: "Out of the dust and grime they come, and lead themselves to the waves for a thorough washing, and off comes the soot and soil from the bodies and down come the cobwebs from the brains and we send them back born again."

At that time, Rehoboth, Delaware, Ocean City, Maryland and Atlantic City, New Jersey, had excellent rail connections with the big cities, and trains carried thousands of vacationers to the beach every summer. Bethany Beach had no rail connection, and there was little prospect that it would ever have one. About 1904, the *Bethany Herald* proudly published a little ditty:

*Ocean City has one railroad,*
*Rehoboth two can claim;*
*Bethany Beach has none at all,*
*But we get there just the same.*

Bethany Blossoms at the Beach

# BETHANY BUILDS

The trip to Bethany Beach may have been cumbersome, but vacationers continued to make their way to the resort. Some of these visitors liked the area so much that they decided to call Bethany their home. In 1910, the U.S. census put the town's population at fifty-six permanent residents, many

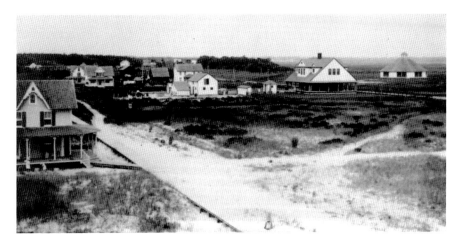

In the early years, there were wide tracts of sand between the houses. *Courtesy of the Town of Bethany Beach.*

William Errett, enjoying the porch of his home. *Courtesy of the Town of Bethany Beach.*

of whom lived in spacious summer homes that were large and solidly built. Unlike the modest "tent houses" that were built in Rehoboth, many of the first homes in Bethany Beach were two-story structures with wide porches and several bedrooms.

Many of the families from western Pennsylvania built houses north of the Auditorium, and that area became known as "Little Pittsburgh."

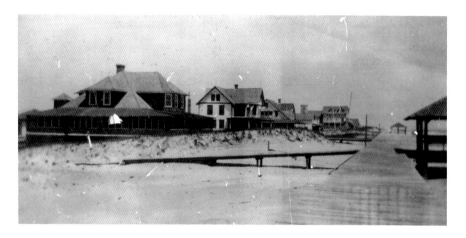

The Drexler House, on the left, sat near the surf. *Courtesy of the Town of Bethany Beach.*

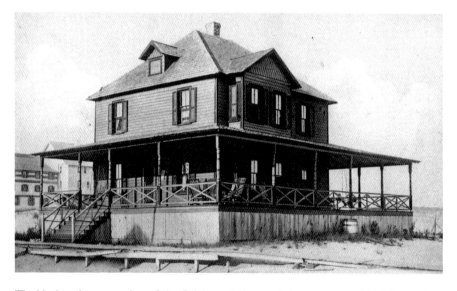

The black and orange colors of the Oriole made it one of the most recognizable houses in Bethany Beach. *Courtesy of the Addy Sea.*

# Bethany Blossoms at the Beach

The Graham family had a striking three-story house with a large deck on the first floor and a smaller deck on the second. A house, creatively named Saltaire, had a windmill that supplied the building with a steady flow of water. The Errett house, built by William R. Errett, a lawyer from Pittsburgh, sprawled over two lots on First Street. The house featured pine tongue-and-groove ceilings and hardwood floors. Louis Drexler, who would serve as a senator in the Delaware state legislature, built a two-story cottage with the obligatory wraparound porch near the beach. The home faced the surf, which often washed up near the front porch, and it was dubbed the Breakers. Among the many family members who enjoyed walking down the front steps of the Drexler home and stepping into the surf were his two sons, Henry Clay and Louis.

Perhaps the most colorful building in town stood on Atlantic Avenue. It was painted a striking orange and black and named the Oriole.

John Matthew Addy built one of the first houses and set the standard for others at the resort. Addy was a plumber from Pittsburgh, and he shipped supplies from his hometown to give his house, the Addy Sea, all of the modern conveniences.

The owners of many of these spacious homes often took in friends and family for a stay at the beach. Vacationers without friends or family could stay at the Sussex Hotel or the much larger Bellevue-Atlantic, which later

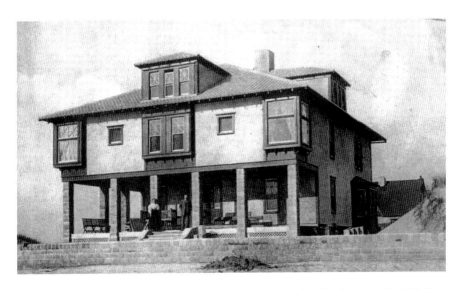

The Addy Sea has been one of Bethany's most enduring landmarks. *Courtesy of the Addy Sea.*

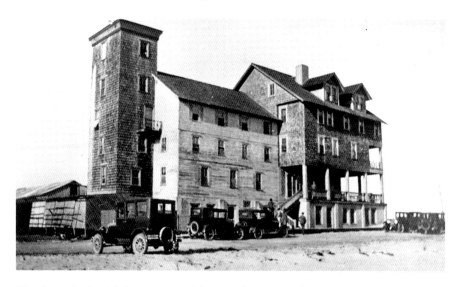

The distinctive Seaside Inn was one of the resort's most popular hotels. *Courtesy of the Delaware Public Archives.*

became known as the Seaside Inn. This unusual-looking structure featured a raised four-story building with dormer windows that faced the beach. Connected to this was a smaller building and a stubby, square tower. From a distance, the Seaside Inn looked like an enormous train engine that had backed up to the beach.

In addition to the Seaside Inn, vacationers could stay at the "Weneeda Rest," which was described as

> *a very simple lodging place…a story and half high with six rooms unplastered and unceiled* [without a finished ceiling], *and just a hundred feet from the surf. The sea rolls in and breaks near the door, and breaths through every opening and sings its lullabies in our ears all through the day and night, and brings heal and contentment and food and comfort and cleansing and well-nigh every good thing.*

A short distance from the beach stood a large building that the fraternity Sigma Alpha Epsilon adopted as its summer lodge. Founded in 1856 at the University of Alabama at Tuscaloosa, the Sigma Alpha Epsilon fraternity had houses at many prominent colleges, and it proudly listed President William McKinley as a member. At the beginning of the twentieth century, many members from the Philadelphia area were looking for a place to meet

# Bethany Blossoms at the Beach

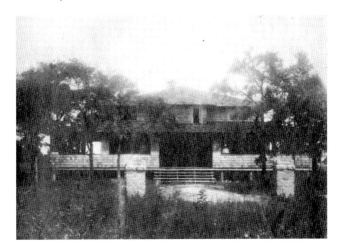

The Alpha Epsilon's summer lodge would become known as the "Club House." *Courtesy of the Town of Bethany Beach.*

during the summer months, and their search brought them to Bethany Beach. Unfortunately, the frat brothers' geographical knowledge was as limited as that of William Penn and Lord Baltimore. The fraternity brothers described their new summer lodge as being in Ocean View when, in fact, it was located on the west side of Bethany.

In the March 1904 issue of the fraternity's journal, E.C.A. Moyer described the group's new summer gathering place:

> *The house is excellent adapted to the purpose for which it is designed, that is, the entertainment of either a stag or house party. All who have seen it unite in declaring it to be an ideal building. It is a substantial two-story structure, having a partially enclosed veranda on three sides. The first floor embraces a large living room and a dining room—separated by a huge double fireplace—a butler's pantry and a kitchen. The story above includes five sleeping apartments, two bathrooms and a large hall, used as a library and writing room.*

Like many other houses in Bethany Beach, the Alpha Epsilon's summer lodge had a spacious porch that wrapped around three sides of the building. According to Moyer, "The veranda, dining and living rooms being on a level and equipped with hardwood floors, furnish an excellent dance hall. The outside dimensions, including veranda, are sixty-feet on the front, by forty-six feet in depth, while the interior measures forty-two by thirty-four feet."

In front of the house stood two distinctive stone pillars that were nicknamed "Boaz" and "Jachin." The fraternity house was situated in the center of an

acre of ground that was located not far from the beach, which was "piled high with sand dunes as far as the eye can reach."

According to Moyer, "The beach abounds in natural advantages, unsurpassed by any on the Atlantic coast. The strand has no superior and few equal. Indian River and bay close by furnish good boating and fishing of every description."

After the first year, the summer fraternity house seemed so popular that the fraternity contemplated expanding the project. The popularity of the summer lodge, however, was short-lived. The building was taken over by D.C. France of Philadelphia and became known as the "Club House."

The architecture of Bethany underwent a major change in 1907 when the Bethany Beach Life-Saving Station was erected on the beach north of Fifth Street. Unlike the other lifesaving stations that were built along the Delaware coast, the Bethany Beach station was built in the "Duluth" style that included a covered front porch, a large gambrel roof and other architectural touches that marked the Colonial Revival style.

One of the most distinctive features of the Bethany Beach station was a four-story lookout tower, with a cantilevered observation floor. The wider top floor made the tower look a little like a blockhouse from a western stockade. The observation floor provided the lookouts with an excellent view of the Atlantic, and they could also see over the beach houses to the Tabernacle.

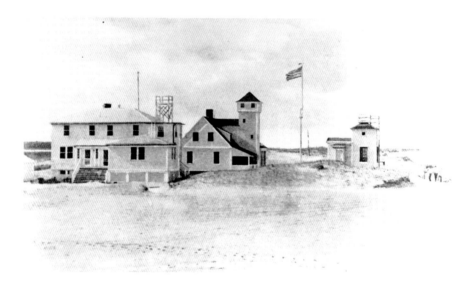

The lookout tower of the lifesaving station gave the surfmen an excellent view of the ocean. *Courtesy of the Indian River Life-Saving Station Museum.*

# Bethany Blossoms at the Beach

The keeper of the new station was Washington Vickers, who had transferred from Indian River Inlet to take charge of the Bethany Beach surfmen. Vickers decided to give himself a makeover when he assumed his new post, and he shaved his full white beard that had made him instantly recognizable through the coastal communities. Wearing only a modest mustache, many of his friends failed to recognize the Seaford native on Bethany Beach.

Just as the Tabernacle provided interesting programs for vacationers, the crew of the lifesaving station provided late summer beach visitors with an afternoon's diversion. According to regulations established by the Life-Saving Service, Tuesdays and Thursdays were set aside for drills with the Lyle gun, breeches buoy and other equipment. On the other weekdays, the men worked with the lifeboat, lines, blocks and other equipment. In addition, they attended lessons on the international signal code and drilled on the resuscitation of drowned persons. Saturday was devoted to housecleaning chores, and Sunday was a day of rest.

Whenever the surfmen of the lifesaving station drilled on the beach, they attracted curious onlookers who were delighted by the skill of the surfmen, working under the watchful eye of Keeper Vickers. The firing of the Lyle gun to throw a line to a stranded vessel may have been the most spectacular activity performed by the surfmen. The small, toy-like cannon boomed as it shot the line toward a supposed ship in distress. Landlubber onlookers were also deeply impressed when Vickers had his crew launch a surfboat through the churning Bethany Beach breakers.

When Vickers took command of the station at Bethany Beach, he shaved his distinctive beard. *Courtesy of the Indian River Life-Saving Station Museum.*

Surfmen drill with the Lyle gun, which was used to throw a line to a ship in distress. *Courtesy of the Town of Bethany Beach.*

In addition to Vickers, the crew of the lifesaving station was peppered with men from families who had lived in the coastal area for generations. It was the custom to furlough the surfmen during June and July, when the mild summer weather posed little threat to mariners. The *Bethany Beach Booster* reported in 1912:

> *Bethany Beach Life-Saving Crew resumed business at the old stand August 1, having been laid off from station two months. Captain Vickers still continues in charge. The other men are S.B. Hitchens, T.E. Dukes, Havery James, Horace Harmon, H.B. Bunting, John J. Short; steward of the mess, Harry Knox.*

Bethany Blossoms at the Beach

## BATHING MORE REFRESHING

Although vacationers to early Bethany enjoyed attending lectures at the Auditorium and watching Vickers and the surfmen drill, early visitors to the resort also spent a great deal of their time frolicking on the beach. In the early twentieth century, beachgoers wore bathing suits inherited from the Victorian era. Women wore suits with blouses and bloomers—which could be worn with or without stockings, provided the bloomers were full and extended to at least four inches above the knee. Men wore shirts along with their trunks, which also had to reach to within four inches of the knee. The bathing costume often was accessorized with long black stockings, laced-up bathing slippers and fancy caps. Since neither men nor women did much swimming in the ocean, a trip to the surf was considered a saltwater bath—and so they named their apparel "bathing suits."

Power proclaimed, "Never was the ocean more majestic, the sunrises and sunsets more beautiful…the bathing more refreshing, or the people kindlier and happier. It has been a great summer at Bethany-beside-the-sea."

Enjoying a moment on the beach in the early resort. *Courtesy of the Town of Bethany Beach.*

Beach attire a century ago was not designed for swimming. *Courtesy of the Town of Bethany Beach.*

Although enjoying the surf was one diversion at Bethany, the beach was another. According to Power, "Here is the sand. This tiny commonwealth has grains enough and to spare and it is white and clean and beautiful. Great dunes, graceful and picturesque, line the shore, running back sometimes a hundred yards or more and between waves and eddies [are] tons of soft and snowy sand."

Power also noted:

> *"First in a child's outfit," somebody says, "should be a sand heap." Almost the first thing that human beings want to do after they learn to eat is to dig. A cart load of sand is one of the cheapest and most satisfying playthings in the world. It is worth a houseful of dolls and painted monkeys on sticks.*

In addition to a cool dip in the breakers, playing on the sand and boating on the coastal bays, some of the vacationers at Bethany enjoyed an annual masquerade party. In August 1911, visitors to the resort dressed in an assortment of creative costumes for a party in the Club House. Fourteen-year-old participant Mary Else donned a brown dress trimmed with red fringe and embroidered with beads, and she went dressed as Pocahontas,

## Bethany Blossoms at the Beach

Two masqueraders enjoying some time on the beach. *Courtesy of the Town of Bethany Beach.*

complete with brown stockings and moccasins. Mary wore a tight band around her head and braided her long hair into two pigtails with a feather to top off the outfit. Other partiers dressed as harem girls, sailors, Little Red Riding Hood, servants and a variety of other characters.

The next year, the *Bethany Beach Booster* reported:

> *The masquerade party given at the Club House night of August 16 provided a great success. Lots of fun and merry dancing. Mrs. Parrot dressed in an old Negro mammy costume, carrying a good-sized rolling pin to defend herself from the dirty white trash, was unanimously voted as the biggest make up at the ball.*

Although most days at the beach were pleasant, the resort experienced an occasional blot on its reputation. In 1912, the *Booster* reported:

> *On the Morning of July 31 the cottage know on in the Woodland Subdivision as the Robinson house, near the County Club House was found broken open, things inside generally scattered about, bureaus and boxes ransacked, but nothing of moment found missing by Mr. Smith Evans, who had his household goods stored there while he and wife are living in Pioneer Cottage with Mr. and Mrs. France. It is thought some of the mischievous boys scouting about the beach were the perpetrators of the crime, for it is well known that the natives or their children would not be found guilty of such a proceeding.*

Despite these transgressions, the same issue of the *Booster* also reported that

> *Mrs. Laura V. Given, housemother of the Bessie Memorial Boarding Home, 2052 Catherine Street, Philadelphia…was highly pleased with Bethany Beach and was astonished when the Booster man told her that no arrest but one had been made here in twelve years; thought the place was just lovely and hoped that in some way she might some day be able to bring the thirty-five young girls under her care to this beautiful spot for an outing.*

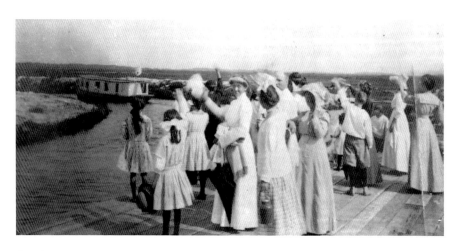

Greeting the boat at the Loop Canal. *Courtesy of the Town of Bethany Beach.*

# Bethany Blossoms at the Beach

As the resort grew, the town continued to make improvements. In 1912, outhouses were constructed on the Auditorium grounds, and a pavilion was built on the southern section of the boardwalk. "It cost $95, and is located on the ocean boardwalk almost in front of the Sussex House. Fine improvement."

The town commissioners also ordered that additional streetlamps be erected in town. At that time, the lamplighter's salary was fifteen dollars per month, and the garbage collector received one dollar per day for his service, including the cost of his horse and wagon. In addition, the commissioners authorized forty-five cents to pay for three wooden stepladders for the use of people to help the official lamplighter to take care of the streetlamps. A stepladder was to be placed at each of the hotels on the beach.

As the summer came to a close, several of the local communities held events in Bethany. The Christian Church at Ocean View hosted a chicken and waffle supper at the Auditorium, and the *Booster* also reported: "Getting sociable! The Methodist Sunday school from Millville, Del., held its annual

Early Second Street, looking toward the ocean, with the Seaside Hotel in the distance on the left. *Courtesy of the Delaware Public Archives.*

picnic at Bethany Beach August 17 and had a good time. Come again. Everybody welcome."

Perhaps the only blight on the 1912 summer was the near drowning of John M. Addy at the Indian River Inlet. Addy was pulled from the water by two fishermen, Henry Cropper and Frank Truitt, who were awarded three dollars apiece for their heroic action. As the year came to a close, the early idyllic days of Bethany were summed up by Lesley S. Graham:

> *Down on the sand dunes of Delaware,*
> *Where the mighty Indian used to roam,*
> *Now a band of Christian people,*
> *Have come to find a seaside home.*
> *From the few who first here gathered,*
> *Quite a colony since has grown,*
> *Cottages both large and small, all handsome,*
> *To the visitor can be shown.*

## Drexler's Dream

During the nineteenth century, families with familiar Sussex names—such as Williams, Townsend, Evans and Dukes—built homes several miles inland from the beach. When a railroad line was constructed from Georgetown to Selbyville, the train revolutionized travel in the coastal region, and boat traffic on the coastal bays decreased. Prodded on by the arrival of the railroad, the population near the road that stretched from the beach to inland communities continued to grow; it began to coalesce into a town around a general store operated by Elisha Dukes. When Dukes's store was selected as the site for a new post office, it needed a name. Considering the prominence of the Dukes family, some area residents suggested "Dukesville" or "Dukestown." Others believed that the community should be named after the area's sawmills and gristmills that produced lumber and flour; so "Millville" was officially adopted as the town's name. In 1913, the increased traffic from Millville to the railroad station led to the straightening of the old road as it led inland. The improved route was able to reduce the length of the road from twelve miles to eight.

As the inland areas grew, Bethany began a fundamental change, but the shift was so subtle that few people noticed. That year, the resort was busy, and some hotels were filled for the summer season. There continued to be a

large number of vacationers from Pittsburgh, Johnstown and other western communities; in past years, there were a variety of events at the Auditorium. The *Booster* reported:

> *The Chautauqua exercises at Bethany Beach this season were up to standard, and Sunday services at the Auditorium all were that could be expected. Rev. Earle Wilfley of Washington City, was in charge. Rev. Mr. Townsend of Hagerstown, Md., a former resident of Sussex County, Delaware, delivered one sermon and one lecture. Rev. E.B. Bably, of Baltimore the same; Mr. Downing of the Department of Agriculture, one lecture, and Rev. G.W. Remagen, of Ocean View Christian Church, one sermon. Mr. Wilfley did the rest of the speaking. Former Senator Drexler aced as Superintendent o the Sunday School, Mrs. Drexler presided at the piano, and Squire Henderson looked out for the building and saw that everybody was comfortably seated. The picture shows by Dr. Wilfley were fine, and attracted large audiences. The financial outcome was finer still. All expenses incurred were paid by voluntary contributions, and there was a balance left over sufficient to make repairs in the roof of the building.*

Having collected enough money to repair the Auditorium, the town hired local contractors Henry May Evans and Allen F. Evans, who sold "all kinds [of] shingles, nails lumber, and building material." According to the *Booster*, "The Auditorium building, we are happy to state, is still in good condition. Evans and Evans has contracted to repair the roof at a cost of fifteen dollars and put a galvanized nail in each shingle." In addition to the usual programs at the Auditorium, groups from Ocean View and Millville continued to make the short trip to Bethany to enjoy a day at the beach. In 1913, the Ocean View Christian Church called off its meetings for four Sundays so that its members could worship at the beach during the Chautauqua exercises.

Despite this success, the difficulty of traveling to Bethany Beach remained. The *Booster* saw a glimmer of hope when it reported:

> *The U.S. Government Engineer at Wilmington has lately let contracts for dredging the canal connecting Delaware Bay with Rehoboth Bay, which improvement the people down in this section have been praying for many years. It is reported that the $45,000 is now available to start the work. It is now freely predicted that within two years' time boats will be running daily between Lewes, Del. and Ocean City, Md., by the Inland route. Hurrah! For Bethany Beach.*

One of the most popular boats was the *Allie May*, a small steamboat that could navigate some of the shallows found in the coastal bays. *Courtesy of the Town of Bethany Beach.*

As picturesque as the small steamers that carried vacationers down the Loop Canal into town were, their capacity was limited, and they were being challenged by the growing popularity of cars. Although horseless carriages had been around for over a decade and were constantly being improved, driving to Bethany meant negotiating miles of deeply rutted, unpaved roads. To rectify the sorry state of Delaware roads, wealthy Delaware businessman T. Colman du Pont, proposed building a modern, hard-surfaced highway from Selbyville to Wilmington and presented it to the state as his gift. When the state law authorizing the acceptance of this generous offer was challenged in court, it appeared that Delaware roads might remain in their medieval condition. In 1913, however, the *Bethany Beach Booster* was able to report:

> *The Supreme Court of Delaware has decided that the DuPont Boulevard law is constitutional. Go ahead, Boulevard! Everything leads toward Bethany Beach, the leading Christian seaside resort in the country.*

# Bethany Blossoms at the Beach

Early Ocean View motorists ready for a Sunday drive. *Courtesy of the Ocean View Historical Society.*

The news of this decision was happily received at the Breakers, where former state senator Drexler and his family usually had a house full of people. Drexler delighted in taking his guests boating and fishing, but his passion was driving visitors around the sandy coastal roads in his car. In August 1913, a meeting was convened in Rehoboth Beach to organize the Sussex County Automobile Association, and Drexler was eager to attend; however, the wild dunes between Rehoboth and Bethany were too formidable for any car to navigate. Drexler was forced to attend the car conference by boat.

In some Delaware communities, cars were becoming common. By 1910, there were so many cars in Lewes that the town council imposed a speed limit of eight miles per hour for all cars operating on the town's streets. In addition, the town council mandated that all cars had to be equipped with a light for night driving and that drivers were required to blow their horns at every intersection.

Although the leaders of Lewes had to contend with the growing number of automobiles on the town's streets, Bethany Beach had no such problem. As Senator Drexler (who was from Pittsburgh) was well aware, it took an intrepid traveler to reach Bethany. Construction on the Du Pont Highway had barely begun in 1913 when Drexler and other automobile owners met in Rehoboth. Drexler's inability to travel from Bethany to Rehoboth by car highlighted the need for a road that linked the two seaside resorts,

and whatever embarrassment his arrival by boat may have generated was dispelled by the growing popularity of cars. One day, Drexler believed, there would be a road across the dunes linking Bethany and Rehoboth.

Although highway construction in Delaware was slowed by the American entry into World War I, by the 1920s cars had become commonplace on Delaware roads; however, there was still no link between the seaside resorts. In the 1920s, the completion of the Du Pont Highway allowed more vacationers to drive to the beach, and Drexler continued to push for the construction of a hard-surfaced road along the coast. Twenty years later, that dream became a reality, and the *Delaware Coast News* reported:

> *It was Senator Drexler's own dream, and regardless of what personal interest he may have had in the project, it was a far-sighted glimpse which looked into many tomorrows when suitable ocean sites will be at a premium. About thirteen miles of Senator Drexler's dream has come true.*

The *Bethany Beach Booster* had recognized his tenacity in 1913:

> *Former Senator Drexler, the Bull Moose leader of Delaware, is still at the beach. The Bosses have not driven him away yet. The young Napoleon from Muddy Neck at the next election should be sent back to Dover by all manner of means. He, while there before, showed the people that no boss, corporation, or railroad could control his action when the best interests of the people were at stake. Independence in our representative is what is wanted and needed. Drexler has lately proven a godsend to Bethany Beach people.*

It would take many years, but as the roads improved, visitors to Bethany Beach would not have to contend with trains, boats and carriages to reach the resort. The shift in transportation would mean that Bethany would one day become a thriving resort for hundreds of thousands of vacationers.

Although that transformation would be slow in coming, the *Booster* announced another pending change in 1913 that would take a steady hand from the community:

> *Capt. and Mrs. Vickers are still at the Life-Saving Station. Their house, lately built in Georgetown, Del., has been furnished and is ready for occupancy when the Captain concludes to leave the Government service.*

# Bethany Blossoms at the Beach

Keeper Vickers belonged to a generation of lifesavers who braved wind and weather to assist those on ships in distress. By the time Drexler was driving on the sands of Bethany Beach, Guglielmo Marconi had invented a rudimentary radio system that was the forerunner of a variety of changes that would alter life in the coastal communities. Marconi's early wireless system was capable of transmitting only the dots and dashes of Morse code, and it seemed best suited to improve shipboard communication. By the first decade of the twentieth century, many large ships had been equipped with wireless telegraph equipment, and a series of wireless stations had been established along the Atlantic coast—including one at Bethany Beach.

The wireless station in the resort was part of a radio navigation system that enabled captains to ascertain their positions as they made their way along the coast. When a captain nearing the entrance to Delaware Bay would broadcast his call sign, it was picked up by the stations at Bethany, Cape Henlopen and Cape May. At each station, the wireless crew noted the compass heading of the incoming signal. The three headings were relayed to the Cape Henlopen station, where the crew used a map and pieces of string to plot the direction of each signal. The three strings intersected at the vessel's location, which could be relayed to the captain of the ship.

The wireless station at Bethany remained part of the radio compass system for a number of years. During that time, the reception of "dot dot dot, dash dash dash, dot dot dot" of an SOS caused the wireless operators to spring into action to save a ship in distress. Eventually, the development of more sophisticated equipment made the wireless station obsolete, and it was abandoned. As the demands of the modern world grew, the old Life-Saving Service became part of the Coast Guard, and many surfmen and keepers, such as Washington Vickers, retired to a more leisurely life.

## Chapter 4
# DIGGERS AND SHAKERS

### Modern War off Bethany

When vacationers arrived along the southern Delaware coast in 1917, the United States was at war, and Bethany Beach was within sight of the enemy. Some older residents of Ocean View and Millville could recall the threat to the coast two decades earlier during the Spanish-American War, when there was a fear that enemy warships might arrive off the Delaware beach and shell coastal communities. That threat never materialized, but during World War I enemy warships did arrive off Bethany Beach.

During the first decades of the twentieth century, the number of sailing ships that passed the beach at Bethany was steadily decreasing, as shipyards around the world were turning out steel-hulled ships with steam, diesel and electric engines. The new technology made possible a vessel straight from the pages of Jules Verne: the submarine. The United States' entry into the war had been precipitated by the sinking of the *Lusitania* and other attacks by German submarines. The American authorities were well aware of the threat that these vessels presented.

Days after war was declared, the Naval Coast Defense Reserve was expanded to guard the waters off Bethany and the rest of the Delaware shore. Sailors in the reserve would serve on submarine chasers and minesweepers to counter Germany submarines that might visit Delaware waters. In addition, men would be assigned to augment the Coast Guard by serving as lookouts at various points along the coast. While on active duty, members of the reserve received the regular navy pay according to their

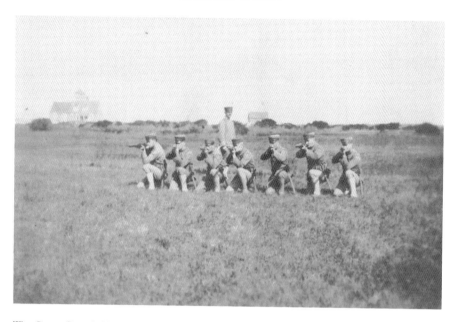

The Coast Guard drills on the Delaware coast. *Courtesy of the Indian River Inlet Life-Saving Station.*

rank. In addition, the men received twelve dollars per year while not on active duty.

Although most of the German submarines remained in European waters, the fear of an enemy attack caused some captains to steer their ships a little closer to the Delaware coast; throughout the first year of the war, visitors to Bethany Beach witnessed a steady stream of merchant ships making their way along the cost. By September 1918, it appeared that the war was entering its final stage, and many Americans were confident that the enemy had left coastal waters. They were wrong!

On July 20, 1918, one of Germany's most modern submarines, the *U-117*, left Germany and steamed across the Atlantic. The primary mission of the sleek, 267-foot-long submarine was to plant mines in the busy shipping lanes along the coast. After torpedoing a tanker and sinking a schooner with its deck guns, the *U-117* arrived in Delaware waters. In August, the vacation season was at its height when the German submarine arrived off the Delaware beach. The *U-117* was difficult to spot when it cruised on the surface. When the U-boat submerged, it could not be seen at all, and the crew of the German submarine were able to perform their deadly mission without being seen by vacationers. The crew of the *U-117* methodically

planted a field of lethal mines off the Delaware coast south of Bethany; with its mission completed, the submarine headed back to Germany.

The German submarine had been gone for nearly a month when the USS *Minnesota* reached the southern Delaware coast. By the last week of September, nearly all vacationers had left Bethany, and only the permanent residents were on hand to see the powerful American battleship. Built in 1907, the four-hundred-fifty-six-foot-long *Minnesota* was one of America's most modern battleships. A product of America's growing industrial might, the *Minnesota*'s large twelve-inch guns could blow most other vessels out of the water. A decade earlier, as part of the Great White Fleet, the *Minnesota* had sailed around the world to demonstrate America's naval prowess.

In September 1918, the deadlock of World War I appeared to be breaking. The exhausted German army was near collapse, much of the German navy was bottled up in European ports by the Allies and some were predicting that the fighting would be over in a matter of weeks. With little fear of a German attack, the *Minnesota* blithely sailed the Delaware coast between Bethany Beach and Fenwick Island through waters that had recently been visited by the submarine *U-117*.

The quiet cruise of the *Minnesota* along the southern Delaware coast was interrupted when it struck one of the mines left by the sub. The explosion ripped a large hole in the ship's hull, and the sea began to flood the battleship. After the stunning realization that their ship had been severely damaged, the crew of the *Minnesota* took immediate action. In addition to having modern armament, the *Minnesota* was subdivided into a series of watertight compartments, and the American sailors quickly closed and locked the hatches that connected these compartments. Although badly damaged, the *Minnesota* headed northward to Philadelphia, where it was able to make repairs. The modern construction of the ship and the discipline of the crew had saved the ship.

Several days after the *Minnesota* had been damaged by one of the mines left by the *U-117*, the cargo ship *Saetia* entered the minefield south of Bethany Beach. The *Saeita* lacked the heavy construction and watertight compartments of the battleship *Minnesota*. When the cargo vessel encountered a German mine, the blast ripped the ship apart. The *Saeita* began filling with water quickly, and the crew raced to launch the lifeboats. Although there was no hope for the *Saeita*, which disappeared beneath the waves, the ship's crewmen were rescued by the Coast Guard.

The destruction of the *Saetia* and the damage to the *Minnesota* in the waning days of World War I demonstrated the power of German submarines.

Modern naval warfare would be a lot different from the age of fighting under sail. Two decades later, during World War II, Bethany Beach would again be on the front lines, and enemy U-boats would return to Delaware waters with more deadly results.

## Coast Artillery Fires Up

Following the end of World War I and the return of peace, Bethany Beach and the coastal towns were set to resume life as normal. According to a newspaper report in 1918:

> Bethany Beach can boast of some thirty summer homes and a post office. There is also a drug store which is open twice a week only to sell ice cream. A narrow boardwalk stretches along the white sands for about a quarter of a mile.

Although the resort was less than two decades old, and the people of Bethany had already learned to expect an occasional visit by a powerful winter storm, "Parts of this walk are annually carried off by the winter storms but this is no surprise to the tax payers and they patiently vote to build a new one."

In the 1920s, Bethany Beach's year-round population was still less than one hundred, but the completion of the Du Pont Highway in the early 1920s helped spur the construction of additional hard-surfaced roads in southern Delaware. As Delaware roads improved, more and more motorists began to drive down narrow Route 26 through Millville and Ocean View to Bethany Beach.

The damage to the *Minnesota* and the destruction of the *Saetia* raised the specter that in the next war the Delaware coast might come under direct attack by enemy forces; American military authorities were prompt to react. To meet a possible attack on Rehoboth, Bethany Beach and other Delaware seaside communities, the 198th Coast Artillery of the Delaware National Guard was organized as a complete antiaircraft regiment. Drawing on veterans from the 59th Pioneer Infantry who fought in World War I and the old Delaware 1st Infantry Regiment, the 198th gained its federal recognition in July 1921.

With a significant number of the regiment's soldiers hailing from Sussex County, and with a mission to defend the coast, it was only natural that the

# Diggers and Shakers

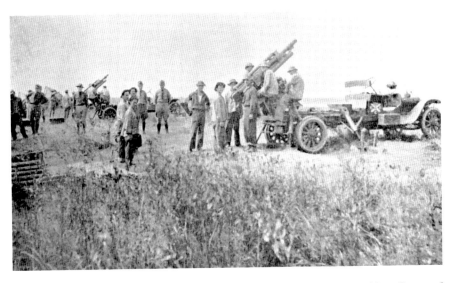

The Coastal Artillery used Bethany Beach to conduct drills with live ammunition. *Courtesy of the Delaware Public Archives.*

198th trained on the beach. A site on the northern edge of Bethany near Salt Pond was secured as permanent National Guard facility. For most of the year, the soldiers drilled in state armories, where they practiced coordinating the simulated firing of the gun batteries, tracking miniature targets and the operation of miniature searchlights from the armory drill floor. For the machine gun battalion, the training included tracking and simulated firing on a miniature target under target practice conditions. In addition to its armory drill, the 198th traveled once a year to Bethany Beach for two weeks of drill and live firing under realistic coastal conditions.

Despite the improvements in Delaware roads, a fully equipped regiment took its time as it crawled across Sussex County to Bethany Beach. In 1929, the 213th Coastal Artillery Regiment, based at Reading, Pennsylvania, traveled to Bethany Beach in a convoy of trucks, trailers, motorcycles and cars. It took this unit (similar in size to the 198th and containing more than 750 soldiers) five hours to travel from Milford to Bethany. A member of the unit wrote:

> *Every unit arrived with its motor equipment in good running order, a splendid tribute to the caliber of enlisted personnel in this regiment…We arrived at Bethany Beach camp area on Monday, the 19th of August, at about noon and everybody busied himself in getting equipment unloaded, the enlisted*

> men in tents and made comfortable, and with the thought uppermost in our minds that we were down there to make some [performance] records.

After spending ten days training, the 213th was preparing to return home when they learned how fickle the coastal weather could be:

> With all of this tucked in our bosoms and our tour of duty to this time blessed with ideal weather conditions we were not to go home without a little of the old war-time conditions of rain, mud, etc., and Thursday night, the 29th, your old "Uncle Davy" sent it down in bucketfuls. So, when we started our departure from the camp site we had real war conditions in moving our heavy equipment. Through the camp area extends a ten or twelve-foot concrete road, and with trucks loading and trying to pass it gave us an opportunity to use our tractor. The minute the wheels went off the concrete they just sank in to the axles, and then it was tractor them out, which, of course, made our tour of duty complete with all the excitement necessary for a troop movement.

The National Guard installation continued to develop; in 1940, the *Coast Artillery Journal* reported:

> Bethany Beach has been utilized by the regiment for its annual camp since 1927, and its location has distinct advantages in many respects. All firing can be conducted from state-owned land over water areas directly in front of positions with a minimum interference from marine traffic. The three-inch guns conducted their practices from a position about four miles from the camp area, while the machine guns were emplaced in a beach position in front of a discontinued Coast Guard station. Therefore it was possible, with two towing planes available, for gun and machine-gun units to fire at the same time without interfering with each other.

When the 198th arrived at Bethany for training exercises, the regiment got down to the serious business of setting up its guns and conducting live firings. Most of the exercises were held late in the day when light and visibility were at their best. As late summer visitors to the resort could testify, the firings created quite a racket that echoed over the dunes:

> The machine gun units began their training by first firing at free balloons. During this time effort was made to select specially qualified gunners from

# Diggers and Shakers

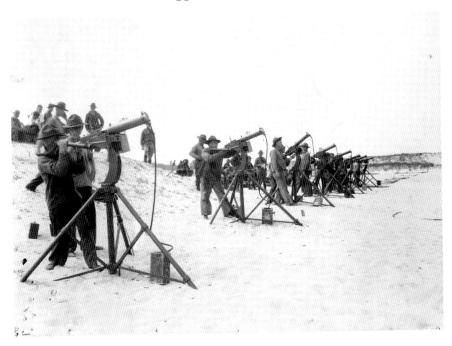

The Coastal Artillery created quite a racket along the beach. *Courtesy of the Delaware Public Archives.*

> *men who never fired the machine gun previously...These preliminary practices, fired by four guns in each unit, were for the purpose of getting the new gunners accustomed to take the proper vertical and lateral leads from tracer observations in order to register on the target...A total of thirty-seven complete practices were fired by the four machine-gun batteries... Each practice consisted of five courses and approximately 2,200 rounds.*

During the nighttime firings, the regiment's three antiaircraft searchlights provided an eerie glow accompanying the cacophony of the guns:

> *Three Speery searchlight units...were received by the regiment just a week preceding the camp period. An extended effort was necessary in order to familiarize searchlight-battery personnel with this entirely new materiel in order to fit it for a searchlight practice during the camp period. One preliminary practice was held during the first week and results when analyzed promised a successful record practice. Unfortunately, bad weather on the night of the scheduled record practice prevented its completion.*

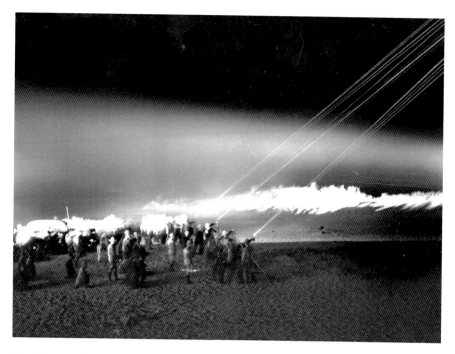

The firings at night were a spectacular sight. *Courtesy of the Delaware Public Archives.*

> *Because there was no lighted landing field in the vicinity of the camp area from which a target plane could take off or land at night, the searchlight battery suffered an abnormal handicap.*

In 1939, the outbreak of war in Europe made training at Bethany Beach especially intense; the members of the Delaware unit demonstrated that they were one of the best-trained regiments in the National Guard. The *Coast Artillery Journal* was effusive in its praise:

> *The spirit of cooperation the Delaware National Guard is the result of years of effort from those who have given freely of their time and energy in the past, and has been the most valuable factor in the progress of the National Guard as a whole. Cooperation is a natural attribute of Delaware, a small state where the inhabitants have the advantage of close and intimate contact with each other, and this is readily apparent among the men of the Delaware National Guard…Colonel Schulz knows what his outfit can do, and does not hesitate to make demands on it when necessary.*

Diggers and Shakers

## BLAST BEFORE ELECTION DAY

Never deep or wide, the Indian River Inlet has always been a fickle waterway that shifted north and south with the whims of the tides and currents. By the time Bethany Beach was established, the ancient waterway that had once marked the northern limit of the coastal towns had silted shut. With no outlet to the ocean, the water in Indian River and Rehoboth Bays became stagnant, and the stench of algae wafted over the coast. The coastal residents were understandably upset, and according to historian Richard Carter, "The closing of the inlet put a stop to the great runs of herring, shad, and other fish in annual spawning runs up the rivers and creeks of the region. Shellfishing grounds were also suffering as a result of the reduced flow in the river and watermen living in the environs of the river and bay found it harder and harder to make a living."

One day before World War I, several hundred farmers armed themselves with shovels and attacked the silt that blocked the inlet. For two days, the men assaulted the muck, and their efforts were rewarded. A channel had been created that allowed water to flow freely from the bay to the ocean, but the victory was short-lived. The wet sand slid back into the watery ditch, and the channel closed. The shovel brigade returned for a second attempt, and they dug a wider waterway, but it was not deep enough for small boats and the algae problems on the bay persisted.

In the 1920s, another, better-organized crew arrived to battle the silt. Led by former governor John G. Townsend Jr., in a war to end all silting wars, the men were armed with the ubiquitous shovels, and they also brought along a mechanical dredge. In addition, they came with several tons of dynamite. Townsend meant to blast the inlet open. He was a Selbyville resident whose wide-ranging dealings included an interest in lumber, strawberries, banks and poultry concerns of Sussex County. Some have even credited him with the invention of the ice cream sundae. Townsend had served as Delaware's governor from 1917 to 1921; during those four years, he had overseen sweeping school reform, revolutionary road construction projects and important social service legislation. In 1928, the former governor had not held elective office for seven years, and the Republican veteran of Delaware politics was running for the United States Senate against the incumbent, Thomas F. Bayard, whose family had been active in Delaware politics for two centuries. Townsend had been appointed to a government commission that was ordered to find a way to reopen the clogged waterway. As election day drew near, Townsend decided to end his campaign against Bayard with a blast.

At that time, the use of explosives to blast ditches was heavily promoted by the Hercules Powder Company. A booklet touted the usefulness of dynamite:

> *Dynamite is at the beck and call of any farmer who has use for it. It can be handled successfully by anyone who will use good judgment and follow directions carefully; and it is safer than some people believe. It is true that due respect must be paid to the powder stored in a cartridge of dynamite or a cap; but millions of pounds are used annually in this country with comparatively few accidents.*

The booklet went on to point out that "the blasting method of constructing ditches may be employed for making almost any open ditch in any type of soil except very thick muck, dry sand, or gravel." This should have given Townsend and his team of ditch diggers pause, but the booklet provided some reassurance: "However when sand or gravel is saturated with water, ditches can be blasted successfully."

Working on a limited budget, Townsend and the commission hired a dredge to prepare the site for blasting. He then persuaded the Hercules Powder Company to donate a ton of dynamite for the project. After both

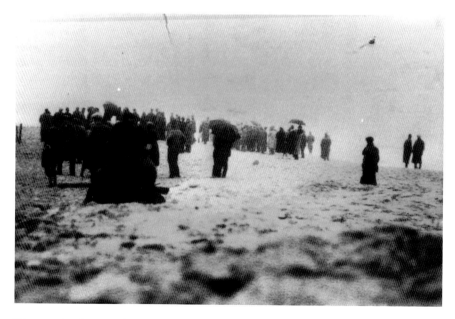

The crowd gathers to witness the big blast. *Courtesy of the Indian River Inlet Life-Saving Station Museum.*

# Diggers and Shakers

The volcanic blast of sand. *Courtesy of the Indian River Inlet Life-Saving Station Museum.*

ends of the channel were dredged, the explosives were assembled in a series of wide, light metal pipes. The sections of the pipes were buried in the sand to form two rows that were two hundred feet long and six feet apart.

On the Saturday before election day, Townsend, members of the inlet commission, other politicians and dignitaries and a curious crowd of several hundred spectators trudged across the sand to see the spectacular reopening of the inlet. After the dynamite had been packed in the sand, curious onlookers were told to take cover; some folks retreated all the way back to Burton Island to escape the effects of the blast. Fittingly, Townsend initiated the explosion, by throwing the switch that would ignite the dynamite. According to historian Richard Carter:

> At four o'clock on Saturday afternoon, November 3, 1928, when the tide was just right, he did so. What was almost certainly the grandest explosion in the history of Sussex County thereupon erupted in what one Wilmington paper called "a volcanic blast of sand."

The explosives were ignited, and the dynamite threw sand 150 feet into the air. It opened a 6-foot-deep and 60-foot-wide channel between the coastal bays and the ocean. Water immediately began to flow between the bay and the ocean, and Townsend's achievement received extensive press coverage throughout Delaware; on election day, he swept to victory.

Before Townsend took his seat in the Senate, the sand on the banks of the new inlet began to slide back into the channel. Within a few months, the new waterway was closed again. For Townsend, however, the opening of

Spectators inspect the dynamiters' handiwork. *Courtesy of the Indian River Inlet Life-Saving Station Museum.*

Townsend (on the left, white shirt) proudly points to the new inlet. *Courtesy of the Indian River Inlet Life-Saving Station Museum.*

the inlet had not been a campaign stunt. When he discovered that the inlet was again shut, he helped secure federal funds to reopen the inlet. In 1934, federal funds became available to reopen the inlet. A short time later, a new channel was dug; this time, the sides of the waterway were stabilized so that the Indian River Inlet became a permanent part of the Delaware coast.

## BOOTLEGGERS CHALLENGE THE COAST

While Townsend was blasting a new channel for the inlet, and the Coast Artillery's gunnery practice was keeping Bethany residents awake at night, there were some who wanted the coast quiet and dark. Southern Delaware had been in the forefront of the movement to ban alcoholic beverages, and in the early twentieth century it was reported that

> *the Temperance people of the state of Delaware have fought long and persistently in order that the state might be rid of rum rule. The liquor element has not been unmindful of the fact that preoccupancy is the vantage ground in any battle. For years it has fortified in bulwark by political intrigue and the lavish expenditure of money, but Old King Alcohol, like Belshazzar, has seen the handwriting on the wall, and his kingdom in the diamond State*

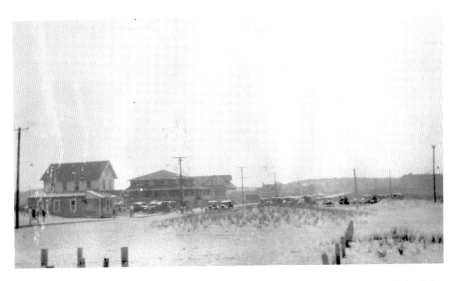

Bethany Beach at a time when bootleggers prowled the coast. *Courtesy of the Indian River Inlet Life-Saving Museum.*

> is already divided. *The tidal wave of Local Option that is sweeping the country, at the special election held in November last* [1907], *landed Kent and Sussex counties safely in the "dry column" with indisputable majorities.*

Sussex County may have been officially dry, but some residents of southern Delaware continued to enjoy a strong drink from time to time. To satisfy this demand, illegal stills were established in the Great Cypress Swamp and other isolated areas. In 1912, the *Bethany Beach Booster* reported:

> *W.C.T.U. should be alert for traveling speakeasies in Baltimore hundred. Last Sunday afternoon at least fifty persons at Bethany Beach witnessed a genuine display of the real stuff dumped into Mrs. Warren's yard by a runaway team that had been left in the street without a driver.*

In 1919, the Eighteenth Amendment to the Constitution was ratified; the manufacture, sale or transportation of intoxicating liquors was outlawed throughout the United States. Prohibition of alcohol did not keep the 1920s from roaring, nor did it keep rumrunners from landing illicit booze on isolated stretches of the Delaware coast.

Some bootleggers began their run to the beaches of Sussex County in Canada, where they loaded small boats with metal containers filled with illegal alcohol. The rectangular shape of the containers made them easy to stack on the small vessels. Each container was covered with a cloth sack so that it could be handled quietly. The cloth covering also prevented the tins from reflecting light that would reveal the bootleggers' position.

When the rumrunners' vessel reached the Delaware coast, the bootleggers remained beyond the three-mile limit, where they were safe from interference from the Coast Guard. After night had fallen, the illegal alcohol would be loaded into small boats for the final run to the beach. After they reached the beach, the bootleggers would reload the metal containers of booze onto trucks, which would carry the alcohol to big city speakeasies.

Public enthusiasm for Prohibition had been tepid at best; in southern Delaware, many people looked the other way as trucks carrying the illegal booze rumbled from the beach to their inland destinations. Others supported the efforts to end the importation of bootleg liquor, and they would tip off the authorities of an impending delivery.

As recounted by Eric Mills in his book *Chesapeake Rumrunners of the Roaring Twenties*, it was a scene straight out of an early crime movie. On November 28, 1931, James S. Baker, the officer in charge of the Indian River Inlet

Coast Guard Station, received a phone call from an anonymous caller who asked Baker to meet him at the inlet. When Baker reached the inlet, he saw a car with New York plates and four men. One of the men was "Smokey Joe" Cathell, a rumrunner from Long Island. The four had a simple request. They had a boat with a load of booze offshore, and they wanted to land it at Cotton Patch Hills. Presumably, they would truck the illegal liquor through Bethany Beach to inland speakeasies.

The rumrunners were aware that the crew of the Coast Guard kept a careful eye on the coast, and the bootleggers needed them to look the other way while their cargo was landed. When Baker heard what the rumrunners wanted, the Coast Guard officer flatly refused to cooperate. Frustrated by the conscientious Baker, the four rumrunners piled into their Chrysler and headed south into the night toward Bethany Beach.

Shortly after Baker met with the four bootleggers, an informer warned authorities that rumrunners were about to attempt to land a cargo of booze in the Bethany area. The plan was to get the liquor ashore and into the speakeasies in time for Christmas. According to Mills in his study of bootlegging along the coast, five days before Christmas, Baker was met by two men in car. A man who went by the name "Summers" got out, and he made a offer that he hoped Baker would not refuse. Summers told Baker that he would give the Coast Guard officer $500 per night if he looked the other way as liquor from a supply vessel was ferried ashore. This time, Baker played coy and attempted to learn more about the operation, but his questions spooked Summers, who jumped back into the car. As the car sped away, Baker saw that the other occupant was a chicken buyer, Morris Lippmann, from Ocean View.

Amid additional reports that suspected bootleggers were seen in Bethany Beach, the Coast Guard broke the case on January 26, 1932, when 219 sacks of illegal liquor were discovered in a chicken house in Bethany. The booze was confiscated, but the bootleggers got away. With the repeal of Prohibition in 1933, winter nights on the dark streets of Bethany Beach returned to normal.

# A Chicken in Every Pot

The bootleggers who hid their stash in a Bethany Beach chicken house had an Ocean View housewife to thank for the handy building that could easily accommodate more than two hundred containers of liquor. In 1923, Cecile Steele, who raised chickens for their eggs, received a shipment of chicks. Instead of her usual brood of fifty young birds, five hundred chicks

were delivered to the Ocean View resident. At that time, chicken was more expensive than hamburger, and most people considered it a premium meat. Many farm wives raised chickens to produce eggs, which were sold to supplement the family income.

After the unexpectedly large number of chicks arrived, Steele used a piano box as a temporary chicken house, and she began to raise the birds. Young chickens that were tender enough to be fried or cooked in the oven were traditionally a byproduct of the egg industry. "Broilers" were a few of the choicest young birds culled from the old and tough farmyard flock, and Steele set out to raise a small flock of broilers. When her birds reached about two and a half pounds, she was ready to sell her chickens as broilers. At a time when coastal markets sold ham for about twenty cents per pound and bacon for just over thirty cents per pound, Steele received a profitable sixty-two cents per pound for her broilers.

Flushed with success and buoyed by bigger plans, Cecile turned to her husband, Wilmer, a man of many talents. The Ocean View farmer was familiar with soil conditions, weather patterns, planting times, weed control and a host of other subjects that every farmer must know to be successful. In addition, Steele had to improvise, build and maintain much of the apparatus needed to keep a farm in first-class working order. Besides being a farmer, he was also a member of the United States Coast Guard crew that staffed the station at Bethany Beach, and he had to be skilled with the blocks, buoys, boats and other nautical equipment needed to rescue people from ships in distress.

When Cecile told Wilmer that she would need a shed to house her birds, the versatile Ocean View farmer had no problem finding inexpensive lumber to construct the squat red building that became the area's first broiler house. As sales increased and Cecile increased her flock, Wilmer went to work building sheds. Sussex County had an abundance of forests and lumber mills that turned out inexpensive lumber, and Wilmer transformed these into low-cost housing for Cecile's birds.

Cecile's flocks continued to grow at an astounding rate; Wilmer had to build so many sheds that he resigned his position with the Coast Guard to concentrate on the expanding broiler industry. Cecile and Wilmer were soon raising twenty-five thousand broilers per year, and other Ocean View farmers took notice. The mild climate, sandy soil and farmers who were willing to try something new helped make Sussex County an ideal place to raise chickens. In addition, the decline in oystering and fishing in coastal waters created an abundant labor force willing to work in the broiler industry. An energetic farmer could raise several flocks of chickens a year,

# Diggers and Shakers

A coastal farmer and his flock. *Courtesy of the Ocean View Historical Society.*

and if something went wrong with one flock, the year would not be a total loss. By the end of the Roaring Twenties, fleets of trucks loaded with flocks of broilers were speeding up the Du Pont Highway with loads of chickens bound for Philadelphia, New York and other big city markets.

Five years after Wilmer built his first chicken house, there were five hundred farmers in southern Delaware; they combined to raise over one million birds per year. At first, the birds were allowed to run outside the fourteen- by fourteen-foot sheds that housed a brood of chickens, but soon farmers began to contain their birds in the ubiquitous long sheds that still mark the southern Delaware countryside.

During the Roaring Twenties, the broiler industry continued to expand. In his 1928 presidential campaign, Herbert Hoover promised to continue the prosperity and put "a chicken in every pot." After Hoover won the election handily, the farmers of southern Delaware continued to increase production. When the stock market crashed in 1929, the Great Depression began, and millions of Americans lost their jobs. In southern Delaware,

Raising chickens became one of the area's most profitable ventures. *Courtesy of the Ocean View Historical Society.*

however, the broiler industry continued to grow. A decade after Cecile sold her first brood, the Steeles were raising two hundred thousand chickens per year, and the annual production in Sussex County topped six million birds. In addition, broiler production led to the expansion of feed companies, and the need to ship so many birds to market spurred the sale of trucks in the coastal region. While the rest of the country searched for new businesses to replace those that had been wrecked by the Great Depression, raising chickens had quietly displaced strawberry and apple production to become southern Delaware's most important agricultural endeavor.

When Wilmer built his first chicken house, he constructed a simple shed that kept the birds out of the weather, but during the 1930s, chicken houses featured gasoline-powered generators that were backed up by a bank of batteries ensuring that electric pumps would keep a healthy supply of water flowing for the birds. In 1938, the final step in the production cycle was completed when the first dressing plant was opened in Sussex County. It had only been fifteen years since Cecile Steele had asked her husband, Wilmer, to build a chicken shed for her first brood of broilers.

## Chapter 5
# BETHANY AT WAR

### Towers along the Coast

Following World War I, the coastal communities continued to mature. Millville blossomed, and the community that sat astride the road to the coast attracted scores of new residents. To meet the needs of the growing number of schoolchildren, the town's one-room schoolhouse was replaced by a much larger building with four classrooms. In addition, a two-story Masonic Hall was built, and in 1936, the Millville Fire Company was formed.

Although Millville residents had to contend with the economic distress of the Great Depression, the town was lively during the 1930s. Residents enjoyed plays at the Masonic Hall, and on most weekend nights, both sides of the road through the center of town were lined with parked cars. Shoppers from the surrounding area drove to Millville stores, and after they had purchased what they needed, many spent time talking to their neighbors.

At Bethany, the coastal artillery blasted away, the Coast Guard chased rumrunners, the chicken industry grew and vacationers began to go to the movies. In 1923, such epic films as *The Covered Wagon*, *The Hunchback of Notre Dame* and *The Ten Commandments* were released. Ringler Theatre opened on the boardwalk. Patrons sat on folding chairs and bought drinks and popcorn from a soda fountain located on one side of the room. During the early days, before talkies were introduced, Mrs. Neil Ringler Barr played the piano to provide musical accompaniment to the action on the screen. On Saturday nights in the 1930s, the chairs were cleared away after the movie was over, and the theatre was converted into a dance hall.

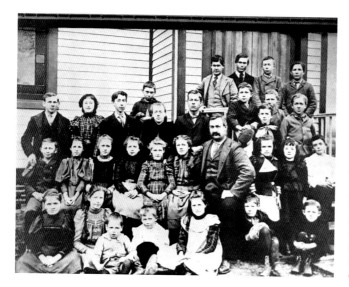

*Left*: Students at the Millville public school. *Courtesy of the Delaware Public Archives.*

*Below*: The Ringler Theatre provided entertainment for the people of the coastal region. *Courtesy of the Town of Bethany Beach.*

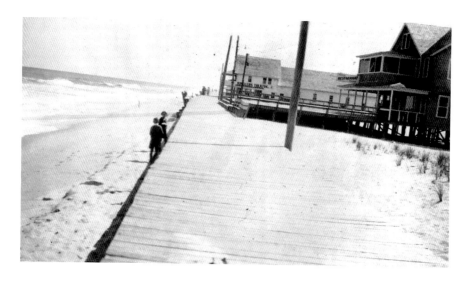

In 1930, the Ringler Theatre was joined by the Wilgus Bowling Alley that featured four lanes for duckpins and two for tenpins. The bowling alley was popular with vacationers and also with winter leagues that drew participants from inland communities. While the coastal communities were developing, on the other side of the Atlantic, the political situation was degenerating toward war. Given America's bittersweet experience in World War I, isolationist feelings ran high in the United States. American military

authorities, however, took a more realistic view of the rise of Adolph Hitler and the Nazi threat. Those responsible for the defense of Delaware Bay realized that advances in weaponry made the defensive works that protected Delaware Bay totally inadequate. In 1940, construction crews arrived on the Delaware coast to begin work on a series of towers and other facilities that would permanently change the landscape around Bethany Beach.

Unlike earlier fortifications that were enclosed by high walls, the new installation contained a series of concrete gun emplacements, barracks, officers' quarters, a mess hall, storage bunkers and other facilities that were spread across the open areas of Cape Henlopen. Taking advantage of the natural camouflage offered by the Delaware sand, the emplacements for several batteries of "disappearing guns" were hidden in the cape's dunes. These large cannons sat behind a concrete embankment that was covered with sand on the seaward side. When the disappearing guns were fired, the recoil drove the barrel back behind its protective concrete shield, where it was locked into place. With the gun lowered, there would be little to reveal the location of the weapon to enemy ships. Protected from the fire of the enemy, the crew of the disappearing gun could reload the weapon in relative safety. When the weapon was ready to fire, the cannon was raised by a hydraulic carriage that enabled the weapon to fire over its protective emplacement. The new fortification was named Fort Miles in honor of Nelson A. Miles, a Civil War general who served in the army for more than a half century.

The sixteen-inch guns at Fort Miles were capable of firing a one-ton shell two dozen miles down the coast past Bethany Beach. The long range of these weapons meant that the shot landed well out of sight of the gunners who fired it. The men who manned the batteries at Cape Henlopen needed spotters to report on the effectiveness of each shot. To house the spotters, a series of eleven concrete spotting towers was built along the beach. Most of these towers were built close to Cape Henlopen, but two were constructed south of the Indian River Inlet. One was built between the inlet and Bethany Beach, and the southernmost tower was south of Bethany.

During the day, lookouts in the towers could spot warships that ventured close to the Delaware coast. When a suspicious ship was spotted, the coordinates were sent by telephone to the plotting room on Cape Henlopen. The coordinates from several towers enabled the plotters to triangulate the position of the ship, and that information was relayed to the gunners. After the order to fire was given, the spotters reported whether the shot was too long or too short, so that the gunners could adjust their aims accordingly. Later in the war, radar was added to the towers so that enemy ships could be detected

The spotting towers for the big guns at Fort Miles provide a sweeping view of the ocean. *Photo by Michael Morgan.*

during bad weather or at night. In addition, Fort Miles was equipped with several six-million-candlepower searchlights that could be used to illuminate any enemy vessel that attempted to approach the coast at night.

The isolationist spirit in America ended on December 7, 1941, when the Japanese attacked Pearl Harbor, plunging the United States into World War II. The lookouts in the towers at Bethany and elsewhere along the coast were put on high alert, but they failed to spot any enemy battleships steaming toward the coast. As was the case during World War I, German submarines would be the real threat to the Delaware coast. In the days after the attack on Pearl Harbor, there was fear that enemy submarines might shell coastal communities, but U-boat commanders had other targets in mind.

Admiral Karl Doenitz, the commander of the German submarine fleet, had devised a plan, Operation *Paukenschlag* (Operation Drumroll), to attack the busy shipping lanes that ran along the American coast. In the middle of December 1941, five German U-boats were dispatched from ports in occupied France with orders to cross the Atlantic and to take up station between Cape Hatteras and the mouth of the St. Lawrence River. Shortly after the German submarines arrived off the American coast, the drumroll of war began to echo across the Delaware coast.

On Tuesday, January 27, 1942, the tanker *Francis Powell* was cruising northward along the coast toward Cape Henlopen. The ship was one of a fleet of tankers that carried vital gasoline and oil that kept factories in Philadelphia, New York and other American cities operating. Aboard the *Francis Powell*, some of the sailors had speculated about the possibility

of a submarine attack, wondering what they would do if such an attack occurred. As the tanker pushed its way through the cold Atlantic waves off the Delaware coast, the American seamen were unaware that a German submarine had spotted the *Francis Powell*.

Aboard the U-boat, the German captain maneuvered his submarine into position. Two hours after midnight, the Germans fired a single torpedo, which struck the *Francis Powell* in the port side with a devastating explosion that crippled the tanker. Water flooded into the *Francis Powell*, which began to settle quickly.

The exploding torpedo jolted Ordinary Seaman John R. Patterson awake. In comments reported by the *Delaware Coast Press,* Patterson recalled:

> *During the past two months that I worked on the Francis Powell the fellows had all kidded about being hit by a torpedo and when I was awakened at 2:35 by a dull thud I know it what it was immediately. I didn't even wait to get dressed. I just made a grab for my life preserver and started to run to the No. 4 lifeboat on the port side.*

With the help of another sailor, Patterson was able to lower the lifeboat into the water. He vividly described the sailors' frantic efforts to abandon the sinking ship:

> *Everything happened so quickly that we had no chance to get scared or think about what might happen. We just worked to get the lifeboat overboard… We were just about to pull away from the tanker—it was already settling low in the water—when some of the men noticed three fellows swimming. Two of them had on life preservers while a third had lost his preserver. We pulled them into the boat and just then the stern of the vessel turned and we were almost struck by the ship propeller.*

As the *Francis Russell* disappeared beneath the waves, the German U-boat slipped quietly away. Most of the crewmen of the American tanker had been asleep when the German torpedo exploded; those in the lifeboats were thinly dressed. No other vessel was in sight as the lifeboats bobbed on the swells, and in the silence, one of the crewmen sarcastically commented, "Well, they might have waited until we had breakfast."

The explosion of the torpedo had destroyed the radio shack aboard the *Francis Powell*, and the tanker had not been able to send an SOS. Fortunately, for those in the lifeboats, the Coast Guard had received an SOS from another ship, and search vessels from several stations in Delaware and Maryland had

been dispatched to look for survivors. After the sun came up, the men in the lifeboats were spotted by the Coast Guard cutter *W.C. Fairbanks*. The men were picked up and taken to Lewes. The sinking of the *Francis Powell* was a grim reminder that Operation *Paukenschlag* had just begun to echo over Bethany Beach and the Delaware coast.

## Five Gallons of Sand

Five days after the attack on Pearl Harbor, the *Delaware Coast Press* printed a list, "Suggestions to Heed during Air Raids." In preparation for a possible attack, residents of Bethany Beach and other coastal communities were advised to know their post warden who would direct emergency equipment and other activities during an attack. "If at home," residents were advised to

> *prepare a refuge room or place of shelter for you and your family…Obtain equipment for extinguishing incendiary bombs. Have a tub ¾ full of water in order to provide a supply of water for an incendiary bomb. Always carry the gas mask while walking or riding. Clear the attic of all combustible material and rubbish. Have at least 5 gallons of sand on each floor.*

Perhaps the most important reminder for residents of Bethany was, "During a blackout, have no lights that will show externally." When German U-boat captains arrived off the Delaware coast, they remained submerged during the day to avoid being seen from the spotting towers of Fort Miles. During the night, submarines could rise to the surface, where their low profile was difficult to see in the darkness. In addition, enemy submarine commanders discovered that during the night the lights of coastal communities helped to silhouette passing ships, making them easy targets. Enforcing the prohibition against lights shining toward the ocean was an important factor in reducing submarine attacks, but it also made Bethany Beach a dim resort during the war years.

The *Delaware Coast News* also listed several things that residents were to do during an actual air raid:

> *If walking, seek shelter; in unfamiliar territory, look for direction signs or seek the Warden. If at home, turn off all running water, gas and electricity. If driving, stop your car, park close to the curb and seek shelter. If riding or driving a horse, unhitch the horse from the vehicle, if any, and tie him to a post by a halter lead. Drive a vehicle carrying explosives or gasoline to an*

*open space before parking...If the gas warning alarm is sounded, don the gas mask. If aware of an incendiary having fallen on combustible material, such as the attic of your home, undertake to put it out immediately.*

After an air raid, residents were advised to check pilot lights to make sure that they were lit, remain at home and, if outside, "avoid interfering by standing about in crowds in order to satisfy your curiosity."

The fear of a direct attack on the Delaware coast began to dissipate by June 1942. The institution of the convoy system for vessels sailing along the Atlantic coast, antisubmarine aircraft patrols and other measures drove most of the German U-boats from American waters. When vacationers arrived in Bethany Beach for the first wartime summer, they discovered chilling reminders of the threats to the resort. In addition to blackout regulations and a dramatic increase in the number of Coast Guard and other military personnel in the resort, armed patrols were being conducted along the sand; those driving between Bethany and Rehoboth Beach were warned not to stop for any reason, even if they had a flat tire. In case of a direct enemy attack on the coast, plans were made to evacuate Bethany Beach, Ocean View, Millville and other communities west of Route 13. A survey was undertaken to determine the number of vehicles available for such a massive move. Those in the Bethany area were to be transported to Seaford. The evacuation plan was never put into effect, but for the next four years, things would remain far from normal along the Delaware coast.

## Enemy on the Beach

During World War II, the Delaware beach between Bethany and Rehoboth was a barren stretch of sand. Except for the Coast Guard station north of the inlet and the spotting towers of Fort Miles, this area of the beach was a ribbon of nearly uninterrupted natural dunes; American military authorities feared that this stretch of the coast would be an attractive landing place for enemy agents. This fear was heightened in June 1942, when two groups of enemy agents slipped ashore near Jacksonville, Florida, and at Amagansett, Long Island. The saboteurs were all apprehended, but along the Delaware coast, the fear of enemy saboteurs landing on the beach remained real.

These fears were heightened in March 1942, when the Federal Bureau of Investigation (FBI) coordinated wide-sweeping raids on twenty-three Delmarva communities. In a front-page story, the *Salisbury Times* reported:

> *Two enemy aliens were arrested by a corps of FBI agents in two day raids on the Eastern Shore of Maryland and Delaware and a quantity of contraband equipment, including swastika armbands and flags were confiscated.*

The confiscated contraband included several hundred rounds of ammunition, rifles, shotguns, short-wave radios, cameras and photographic developing equipment.

One enemy alien was arrested in Delaware, and a second was arrested in Maryland. According to the *Salisbury Times*:

> *The agents acted on leads developed by their own investigation over a long period of time and on reports of "suspicious circumstances" made by residents of the Eastern Shore. Seizures were made under enemy alien regulations which prohibit aliens of the Axis nations from possessing such equipment.*

The raids did little to calm the fears that enemy agents could easily enter the country by slipping ashore on one of Delaware's dark beaches; on the same day of the FBI raid, the small Norwegian freighter *Hvoselff* was torpedoed off the southern Delaware coast. The blast tore the ship apart, and the freighter slipped beneath the waves in less than two minutes. The ship sank so quickly that the Norwegian crewmen were able to launch only the lifeboat on the port side of the *Hvoselff*. The seven sailors in the lifeboat were able to pluck seven other crewmen from the cold Atlantic waters. The ship's captain and five members of the crew were killed in the attack.

The fourteen men in the single lifeboat began to row toward the Delaware coast; thirteen hours later, they landed near Fenwick Island. Although the Norwegian sailors received a friendly reception when they reached the Delaware beach, they had demonstrated how easy it would be for the enemy to slip ashore. German submarines could easily venture to within a few miles of the coast and launch a small boat that could carry a spy or saboteur to the beach.

After the landing of the enemy agents in Florida and New York, the Coast Guard established routine patrols of the nation's beaches. In Delaware, kennels were constructed at Bethany and other spots along the coast, and K-9 patrols of the beach were initiated. At first, the sentries walked the sands each night on foot, but the dunes and sand made foot patrols difficult. The Coast Guard then decided to secure horses and begin mounted patrols. A

stable was established at Bethany beach, and for the rest of the war, the "cavalry" was a common sight on the streets of the resort.

Although the possibility of the landing of an enemy agent on the beach was real, the fear of that happening sometimes rose to paranoid levels when a suspected enemy "agent" was discovered to have successfully infiltrated Fort Miles before making his way to the fort's Surf Club, where he collapsed on the basement floor. When the post engineering officer, Captain Justus B. Naylor, discovered the supposed spy, he was so exhausted that Naylor thought he was dead. After Naylor was able to revive him, it was apparent that he did not understand English, which appeared to confirm the suspicion that the Germans were attempting to land spies and saboteurs on the Delaware coast.

Margaret Hughes managed the Journey's End rooming house, which became "Fort Maggie" for the rest of the war. *Courtesy of the Town of Bethany Beach.*

"Fort Maggie" was a lively place. *Courtesy of the Town of Bethany Beach.*

On July 25, the *New York Times* reported:

> The personnel of Fort Miles, coast artillery post on the Delaware Capes has a "war mystery" which apparently is to remain unsolved forever. What appeared to be a "very dead" dog was found on the basement floor of the fort's Surf club early this week by the post engineering office, Captain Justus B. Naylor, but the dog, a male Gordon setter, proved to be alive, although emaciated and covered with oil and salt water. Its heavy leather collar had no identification. The dog, apparently unused to the English language, will take food from no one except Captain Naylor and growls and jumps at the feet of everyone else who approaches. It sniffs all water thoroughly before drinking. It is known that the Nazi army specializes in the train of Gordon setters. There are various surmises about the dog here. One is that it is refugee from a sunken submarine, another that it was set ashore as a saboteur.

With the influx of military personnel to the beach, housing was in short supply, and several buildings in Bethany were commandeered to fill this need. Naval personnel moved into the old Auditorium, and the rooming house, Journey's End, was taken over and converted into a barracks for the troops. For the much of the war, Journey's End was affectionately nicknamed "Fort Maggie," after Margaret Hughes, who ran the rooming house. Fort Maggie was a hubbub of activity until many of the men of the Army Signal Corps were transferred to new facilities farther inland.

## Drexler's Sacrifice

Gas rationing, massive movements of troops and other wartime conditions made the trip from Delaware to Bath, Maine, doubly difficult for Mrs. Drexler, widow of the state senator Louis Drexler. In September 1944, Mrs. Drexler arrived in Maine to christen a ship named after one of her sons, Henry Clay Drexler. When he was a youngster, Henry and his older brother, Louis, played on the sand at Bethany and watched the surf roll up to the front doorstep of their father's house, the Breakers.

Louis, who was born in 1896, was first to leave the beach at Bethany when he entered the Naval Academy at Annapolis. During World War II, Louis had reached the rank of lieutenant commandeer, and he participated in the invasion of the Philippine Islands. In 1944, he was given leave from duty in the Pacific to travel halfway around the world so that he could join his mother in Maine. A family friend, Miss Ann Scott of Bethany, also joined the Drexlers for the launching of the ship.

In 1920, a few years after Louis left Bethany, Henry Clay Drexler followed in his footsteps, entering the Naval Academy. After graduating in 1924, he was assigned to further training at the New York Naval Yard. Several months later, on October 4, Drexler was assigned to the USS *Trenton*, a new light cruiser that had been commissioned in April. The *Trenton* had completed an extended cruise to the Mediterranean, Red Sea and Persian Gulf when Drexler joined the ship.

Aboard the *Trenton*, Drexler served as one of the gunnery observers as the crew of the cruiser drilled with ship's weapons. Sixteen days after joining the ship, he was in the forward turret when the firing exercise began. To load the large guns on the cruiser, crewmen placed a shell and a bag of explosives, which were brought up from a lower deck by a power hoist, into the breach of the weapon. After the breach was closed and secured, the weapon was fired. The cramped quarters of the turret made firing these weapons hot, dirty, ear-shattering work for the nearly two dozen men in the metal bunker.

At 3:35 p.m. on October 20, while conducting a trial firing of the two six-inch guns in the ship's forward twin mount, a spark ignited one of the powder bags in the hoist; Drexler reacted immediately. He and Boatswain's Mate First Class George Cholister attempted to grab the charges and thrust them into an immersion tank to extinguish the flames. Drexler, without thinking of his own safety, grabbed the charge on the right side of the turret. As he was doing this, the left charge burst into flame and ignited the right charge in Drexler's hands. Before the young Ensign Drexler could thrust it into the tank, the smoldering charge exploded, killing him instantly.

Of the twenty men trapped in the turret, four were killed by the explosion, and ten others passed away from burns and the inhalation of flames and gases. Six others were severely injured, but they survived. Boatswain's Mate Cholister died the day after the accident. For their extraordinary heroism, both Cholister and Drexler were award Congressional Medals of Honor.

In 1944, the navy decided to name a destroyer in Drexler's honor; his mother and brother traveled to Maine for the launching. The Bath, Maine newspaper noted:

> *A mother, whose son gave his life in a brave and desperate attempt to save the lives of 20 of his shipmates, acted as sponsor at the launching Sunday at the yard of the Bath Iron Works Corporation, one of the more fast and powerful first line destroyer, the USS Drexler, named for this heroic young lad, Ensign Henry Clay Drexler, USN. Not in the stress and self-sacrificing atmosphere of battle was this brave deed consummated, but in the normal and peacetime line of duty 20 years ago... A beautiful late Summer day presented a perfect setting for the launching of this fifteenth destroyer to go over from the local shipbuilding plant this year. By 2:30 in the afternoon, the time of the launching, the Carlton bridge and Main Central Railroad station platform was lined with interested spectators who were afforded an excellent view as the craft slid from the northernmost ways of the big shipyard.*

Following the launch, Lieutenant Commander Drexler returned to duty in the Pacific, where the United States was gaining the upper hand against the Japanese. In 1945, the Americans decided to capture Okinawa, which would provide a base within easy flying distance of the main Japanese islands. After it began on April 1, the battle for Okinawa would last for nearly three months, and it became one of the fiercest of the war. While American troops attempted to secure the island, the Japanese launched kamikaze attacks on American ships offshore. Not only was Lieutenant Commander Drexler part of the landing forces, but the ship named for his brother was also part of the American support fleet.

Drexler's principal duty was to survey land prior to having it occupied by troops. After the battle had been raging for nearly six weeks, Drexler was leading a survey team on one of the smaller islands near Okinawa. It was believed that this small island was not inhabited, but there were Japanese soldiers on it; a sniper killed Drexler. Sixteen days later, the USS *Drexler* was sixteen miles from Okinawa when it was attacked by Japanese aircraft. Two suicide planes crashed into the *Drexler*, which rolled over on its side and sank in less than a minute.

# Chapter 6
# TOWNS GROW TOGETHER

### SHINING MEMORY OF THE INDIAN RIVER INLET

After World War II, a long-sought dream became a reality when the Chesapeake Bay Bridge opened to traffic in 1952; the *New York Times* predicted that

> *millions of sweltering residents of Baltimore and Washington will undoubtedly be tempted by the new bridge to explore the surf bathing possibilities that will now be only three or four hours driving time instead of the seven or eight hours because of the long waits for the ferry.*

Not only could motorists could drive across the Chesapeake Bay in a matter of minutes, but when they reached the coastal region, they could also take advantage of improvements to the coastal highway that linked Bethany with Rehoboth to the north and Fenwick Island to south, along with the modernization of east–west Route 26. Many vacationers from the Washington area who drove to the beach stopped at Bethany, and some headed for the inlet. In 1952, the *New York Times* reported:

> *About seven miles below Dewey Beach is Indian River Inlet, one of the most popular fishing spots in the whole region. Here, more than 150 boats, from small outboards to big party boats, are available for fishing either in the ocean or Indian River Bay.*

After a marina and a Coast Guard station were established on the north side of the inlet, it was not long before a number of vacationers and a few permanent residents had moved in. Among these were Paul and Magdaline Barr. Paul was a handyman who had retired from tying fishing lures for a company in Pottstown, Pennsylvania. The Barrs had a house trailer located between the inlet bridge and the Coast Guard station.

Paul added a glassed-in front porch and a bedroom in the back of his trailer, which lacked indoor plumbing. Barr did have a customized outhouse—complete with the traditional little half moon—and a public bathhouse between the Coast Guard station and the bridge provided bathing facilities. The amenities at the inlet may have been primitive, but when the Barrs hosted children, grandchildren and sundry other relatives for a stay at the beach, the house came alive.

One of Paul's granddaughters, Bev Kerr, recalled:

> [The inlet] *was just a sweet little crescent beach, with sand dunes behind it between the trailers and the bay. There were rocks, however, starting at the Coast Guard Station* [and extending] *to the ocean, which ended in the jetty. My brother and I would scamper out to the end of the jetty only at low tide, touch the lighted marker and then scamper back, mashing mussels between our fingers and throwing them to the gulls all the while.*

The first bridge over the stabilized inlet was a timber trestle that was soon replaced by a concrete and steel movable swing bridge just four years later. In 1948, the second span was destroyed by ice flow and extreme tides in an accident that took three lives. Four years later, a concrete and steel swing bridge was built over the inlet; this bridge was in place when Bev Kerr visited her grandfather. She remembered:

> *The bridge in the in the '50s was long and low, two lanes. We would run up the middle of the bridge whooping and hollering, until one of us sighted a car; then we'd run and hug the rail, not much room between the rail and the roadway. It's a miracle none of us ever went end over end off that bridge.*

Dodging cars on the bridge was not the only daredevil stunt that the kids enjoyed:

> *There was a huge sand bar just off this beach. The current between the beach and the sandbar was very, very swift, and it cut pretty deep. We*

*would jump in at the far end of the beach with inner tubes, and the current would literally shoot us out the other end.*

After a particularly long ride on the rip currents, when the kids took a little too long to get back to shore, Bev's mother finally put an end to the practice. Bev recalled:

*She did stop us from finding and jumping into rip currents. Frantically, she found us the last time we did that, after searching for the length of time it took us to be shot out beyond the breakers and swim to shore, then walk back down beach to our blankets. She beat the crap out of us when we showed her what great fun it was to ride a rip current. You couldn't drown us, I am sure she tried. You know boogie boards, well, before boogie boards, we tore the handles off the metal trash can lids and used them. Our dad could not figure out what kept happening to the trash can lids. As far as I know, he never did.*

Those at the inlet ate a lot of caught food, crabs, clams and fish. Bev recalled a nearly disastrous fishing expedition on the sandbar:

*Once all of us were fishing out on the bar when the tide caught us by surprise; us kids saw it and thought what great fun, but the adults who were drinking beers and smoking cigarettes did not. When they did, for us kids, it was the funniest sight. Here was our one uncle carrying the women through the increasing current across to the beach, and my mom frantically digging in the sand for the flounder she had caught. "That's supper; that's supper!" she kept calling out.*

In addition to fishing on the sandbar, she recalled clamming with her grandfather in the coastal bay:

*He would have a half-case of beer between his knees, his pocket knife opened in*

Bev Kerr and a prize catch. *Courtesy of Bev Kerr.*

> his hand waiting for us to pass him our clams from which he plucked the cherrystone clams too small to take back and then to our delight, gobbling them as we watched...hanging from the side of the boat. My cousin Sandy reminded me of the time we were on our way back in, and Pop Pop had perched one of the two overflowing bushel baskets of clams on the bow, hit a wake and the basket flew into the air and went into the bay. She cried and cried. Apparently Pop Pop had told her when he lifted the basket up there that "these are your clams Sandy." Then they went in the drink. I wasn't too worried. "MY" clams were still in the boat.

In the mid-1950s, when her parents also had a trailer at the inlet, a hurricane was churning its way up the coast, and Bev recalled her father's refusal to leave:

> My dad came to tie everything down...My mother was crying to leave as my dad walked around with his lower lip puffed out almost as far as his chest was. A state highway patrolman pulled in and informed us that we had to get out, fast. My dad told him in no uncertain terms we were staying! No words, not my mother's crying nor the patrolman's glare, would change my dad's mind. He pointed out the heavy rope he had tied and staked the trailer with, while shaking his head no. Wordlessly, the patrolman handed him a black grease pencil and told him to write a phone number and who to call on our arms. I will never forget the look of horror on my dad's face. We returned after the storm passed. Leaving, we had to stop to avoid the waves on the highway, the ocean-side dunes had begun to wash out; one wave hit the side of car scooting us sideways. Afterwards, our trailer was the only remaining structure. The power lines that survived looked like a giant hand hung out the wash with bedding, clothing and sheets of metal. One half of our trailer showed where it was end down in a huge water and fish-filled hole. The ropes were gone. My mother never said a word.

When Bev recalled her summers at the inlet, she remembered how her grandfather made sure that she had the proper fishing equipment:

> Pop Pop modified a deep-sea fishing rod for my little hands, and I watched him as he tied lures and flys for my tackle box. He taught me knots, how to cast, and how to throw a net. He also slipped me a jelly glass (no kidding) of whatever he was drinking, most of the time beer but sometimes whiskey, had a turkey on the bottle. He was a good guy.

## Towns Grow Together

The campground near the inlet was often filled with vacationers. *Courtesy of the Indian River Inlet Life-Saving Station Museum.*

The enclave at the inlet ended when the state took over the land and turned it into a park. The beach was bolstered with rocks to prevent erosion, and where her grandfather's trailer stood is now a parking lot. Bev Kerr moved to Ohio in 1972. Since then, she has been back to the Indian River Inlet only twice. Although she lives hundreds of miles from the Delaware coast, thoughts of her summer days along the inlet remain vivid in her mind. "I sat and thought after being asked once about childhood memories, and always the life at the shore, the Inlet, is there shining in my memory, the best time of my entire life."

## Storm over the Coast

While Bev Kerr was enjoying her summers at the Indian River Inlet, vacationers continued to pour into Bethany Beach each summer. Some of these visitors were associated with church groups who stayed in the original Tabernacle and the adjacent dorm. The sleeping arrangements were primitive, with some sleeping on the hallway floors. There were still not enough buildings along the oceanfront to block a view of the sea from the Tabernacle area. From the dorm building, the ocean was visible, and the sound of the crashing waves carried back to the dorm building.

The Tabernacle still retained some of its original spirit, with awnings on the sides that could be rolled up to allow the breezes to blow through. On almost every night, there was some kind of presentation on the Tabernacle's

stage. On the last Thursday of the camp meeting, members from each dorm room would present a skit as part of "talent night." The Auditorium helped the resort retain some of its old-time flavor, but more and more vacationers headed over the Chesapeake Bay Bridge, and Bethany would soon be experiencing some growing pains. In addition, the resort was under a constant threat of being battered by a passing storm.

The Delaware coast has always been prone to the destructive force of storm-driven waves and water, but for eons no permanent residents lived within sight of the surf. The Nanticokes visited the beach for relatively short periods of time, and they were able to slip inland when they were inundated by a major storm. When European settlers arrived in Delaware, most colonists preferred to establish their farms on the fertile ground that was far from the harsh sea spray. It was not until Bethany Beach was established during the dawn of the twentieth century that there was enough significant development along the southern Delaware coast to make this area susceptible to storm damage. In September 1903, a strong storm swept along the coast and gave Bethany's early residents a taste of the power of the wind-driven ocean. Eleven years later, a January storm did considerable damage along the coast; by this time, the residents of Bethany Beach were learning that repairing the boardwalk could be an annual event.

In August 1933, a storm churned its way its way up the Delmarva Peninsula and drove massive waves onto the beaches. At Ocean City, Maryland, the torrential rain filled the coastal bay with water, while the

The 1933 storm ripped through much of the Bethany boardwalk. *Courtesy of the Town of Bethany Beach.*

## Towns Grow Together

hammering waves eroded the beach until a new inlet had been created that severed the Maryland resort from Assateague Island. Having permanently altered the Maryland coast, the hurricane continued northward and took a swipe at Fenwick Island before blasting its way into Bethany Beach. The high wind and water severely damaged the Ringler Theatre and ripped large chunks out of the boardwalk to leave a long row of neatly spaced pilings.

As it had done after other big storms, Bethany Beach residents cleared the debris from the beach, shoveled the sand from its streets and rebuilt the boardwalk. Although it had recovered from the storm, the resort remained a small town surrounded by long stretches of natural beach. In 1952, Nona Brown, a reporter for the *New York Times*, wrote, "Below Indian River Bay, the wild dunes and empty beaches of the state lands continue to the edge of Bethany Beach. Here, again, is a cottage resort of long standing. There is a short boardwalk, with a few shops on it, but the town has very few rooms or cottages for rent on anything less than a month-long or seasonal basis."

The resort's quiet existence, however, was rudely interrupted in March 1962, when the worst storm in Delaware history struck the coast. Nor'easters are dodgy, slow-moving storms that lack the glamour of hurricanes, but as the residents of Bethany discovered in 1962, nor'easters can pack a wallop. On March 6, a high-pressure system over Canada prevented two merging

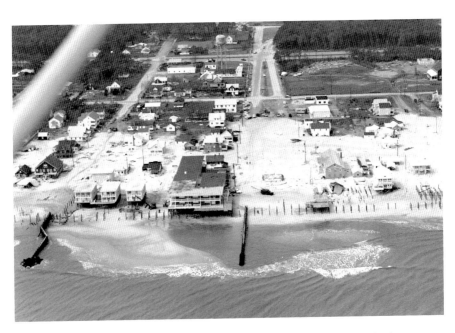

The 1962 storm drove ocean water far inland. *Courtesy of the Town of Bethany Beach.*

low-pressure systems that had formed on the Atlantic coast from moving northward; the result was a disaster in Delaware. For over two days, the nor'easter sat off the coast and sent steady gale-force winds and pounding waves across the beach. During that time, the coast went through five unusually high spring tides; the storm surge smashed through the dunes and reduced beach houses to splintered timbers. At the storm's height, the old inlets that had remained dormant for a century were reopened, and the ocean flowed freely into the coastal bays.

As the nor'easter pounded the coast, it created waves as high as forty feet that breached the dunes in numerous places and drove ocean water flooding through Bethany Beach. An estimated one-third of the beachfront homes were destroyed, with the southern end of town being particularly hard hit. At the height of the storm, the water from the ocean flooded down Atlantic and Pennsylvania Avenues. Route 1 was underwater, and Route 26 was underwater as far as Ocean View.

The storm destroyed more than 1,900 beach homes on the Delaware coast and caused an estimated $400 million in damages. After the rubble was again cleared, the people of Bethany Beach rebuilt; in the years since, the town has experienced an unprecedented building boom. Every few years,

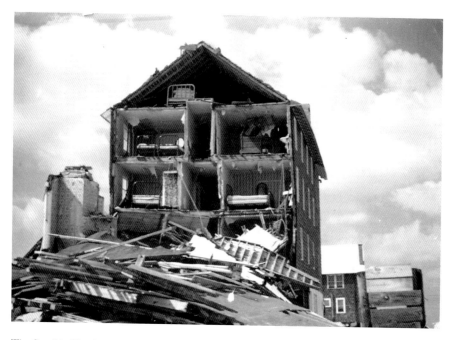

The Seaside Hotel succumbed to the fury of the storm. *Courtesy of the Town of Bethany Beach.*

## Towns Grow Together

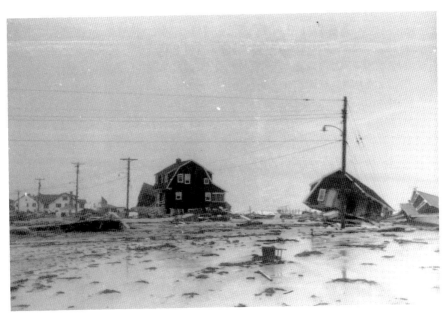

Bethany residents would not soon forget the power of the 1962 storm. *Courtesy of the Town of Bethany Beach.*

however, a powerful storm pounds its way along the coast. As was the case when Tropical Storm Ida flooded the town, the winds eventually abate and the water ultimately subsides. Hurricanes may be the darlings of weather forecasters—who give the storms names and plot their every move—but veteran residents of Bethany Beach are also wary of the plodding nor'easter that can pound the coast for days.

## THE SEARCH FOR MARGARET KINCADE

Bob Elmwood's quest lasted over a half a century. It began on a farm in Michigan, took him to an isolated spot on the Delaware coat and ended on the waterfront in Londonderry, Ireland. Elmwood's personal journey began with a story his grandparents told him in the 1930s. According to family tradition, one of Elwood's ancestors was a survivor of the *Faithful Steward*. She was supposed fourteen years old and traveling to America with her parents and baby brother. An older brother was already in America, and he had arranged for their passage.

When the *Faithful Steward* foundered near the Indian River Inlet in 1785, rescuers from the coastal region gathered on the beach to do whatever they could to assist those who made it ashore. Amid the debris that washed ashore was a teenage girl who had been strapped to a piece of the spar and floated to beach. Her baby brother did not survive. After the dead were buried, the survivors were taken away, probably to Lewes and from there to Philadelphia. According to the *Maryland Gazette*'s account of the disaster:

> *With great pleasure we learn that several humane and public spirited gentlemen of this city* [Philadelphia] *are about raising a subscription, for the relief of the unhappy people who were saved from the wreck of the Faithful Steward; and there can be do doubt of their meeting with great success from the benevolent inhabitants, who have never been backward in affording assistance to the distressed.*

The survivors probably remained in Philadelphia until they recovered from their ordeal; with the help of the funds that had been raised for their relief, they started a new life in America. As the years passed, stories from survivors of the disaster were handed down from generation to generation. The loss of so many members of the Lee family eventually affected General Robert E. Lee, who believed that some of his relatives were in this group. The general was probably mistaken, and he may have based his belief on the false assumption that all of the Lees were closely related.

For sixty years, Bob wondered about the name of his ancestor. Elmwood's search took him to libraries, archives and the sands of the Delaware coast. At each turn, he discovered additional details that enabled him to separate the fact from the fiction of the family tradition. As researched, Elmwood struggled through a web of names—Wallace, Israeloh and Kincade—that were tied into his family. Among these, he believed was the name of his ancestor from the shipwreck.

Bob once told his wife about his ancestor from the *Faithful Steward*: "If and when I ever find her, I have a feeling her name will be Margaret." Elmwood reasoned:

> *My sister's name is Margaret, my mother's name was Margaret, my grandmother Grace's middle name was Margaret, and my great-grandmother (who passed down the story) was named Margaret. There had to be a strong emotional reason for that name to be repeated through so many generations.*

# Towns Grow Together

In the hope of finding some clue to his ancestor, Elmwood came to the Delaware coast. He stopped at the Indian River Inlet Life-Saving Museum, where he discovered that about two miles north of the station there was once a Coin Beach Road that had been named after the coins found on the beach from a shipwreck. Intrigued, Elmwood attempted to explore more, but chest pains and a heart condition cut the expedition short; his quest had not ended, though.

In 2001, Bob was in Europe when he made a side trip to Ireland to continue his research and ended up at the Harbour Museum in Londonderry, Ireland, where the *Faithful Steward* had begun its final journey. At the museum, Elmwood was given a list of survivors of the shipwreck. He later wrote, "The ship's officers and crew all survived—strange. Further, from other accounts, I knew that only 7 women and girls had survived, out of the over 100 women and children on board. I started to read the female names and number 5 leapt out at me—Margaret Kincade." Bob Elmwood had found his ancestor. Margaret Kincade had been the teenager who had floated ashore from the *Faithful Steward*.

When Elmwood came to the realization that he had finally uncovered the name of his ancestor, he was staying at a hotel near the dock where the *Faithful Steward* left for America. He recalled:

> *I went to the front door, stepped out, looked across the street to the quay, where the emigrant ships loaded, then across the river Foyle to a green hill on the other side...and there was a rainbow, arching back toward the river and me. I choked up. It was as if Margaret Kincade were telling me, "You've found your answer at the end of an Irish rainbow."*

## SPLENDID CONCERTS AND SOLOS

Bethany Beach's affinity for music began the day the resort was born. On July 12, 1901, as the crowd sang words that had been especially written for the occasion, the band played "Marching Through Georgia," and the inaugural summer season at Delaware's newest ocean resort was underway. In the years that followed, the resort settled into a routine that saw the first flood of visitors arrive by July 4. After two months, when the resort was crowded with vacationers, schools began to reopen, the days grew shorter, the air began to cool and vacationers started for home. By the middle of September, the resort had settled into its quiet off-season routine.

In Bethany's early days, musical presentations were featured at the Tabernacle and during religious services. Even more impressive were the evening services that were held within sight of the surf. According to an early leader of the resort:

> Who will forget the Sunday sermons and the communion services and the vespers at the beach pavilion! How sweet and holy players and hymns and messages with the accompaniment of the great organ of the mighty deep!

In 1912, Louisa Wrightman expanded on the analogy of the ocean as a musical instrument in song:

> O, Bethany Beach! I am dreaming of Thee!
> I'm hearing the voice of thy murmuring sea.
> O, Bethany Beach! Thou art calling to me!
> In tones ever changing, like moods of the sea.
> Now roar of the breakers as awesome and grand,
> They roll up like mountains, to break on the sand.
> Again the soft purl of their ripple and flow,
> As melody sings to my heart, sweet and low.
> In each of thy changes, my beautiful sea,
> O, Bethany Beach! Thou art calling to me.

During the Roaring Twenties, music at the resort was a bit more up-tempo at the Ringler Theatre, where bands from the local area provided dance tunes. In the early years, when the summer season often opened with patriotic tunes that were part of most Fourth of July celebrations, the summer season usually departed without a whimper in September. Although Labor Day was firmly established as the end of the vacation season, there were those who lamented the lack of a musical exclamation point to mark the end of the annual influx of vacationers. In the 1980s, Moss Wagner, a member of the town council and the owner of an ice cream shop on Garfield Parkway, conceived the idea of holding a jazz funeral for the summer season with the close of business on Labor Day. Styled after funerals held in New Orleans, the farewell to summer celebrations featured a parade of musicians and the public to mark a lighthearted end to the vacation season. The annual Jazz Funeral has become a permanent event that continues the Bethany Beach's musical tradition that began over a century ago, when the tune of "Marching Through Georgia" opened the newly established resort for its first summer season.

Towns Grow Together

# THE KUSKARWAROAKS LOOK TO THE LAND

In the twenty-first century, Bethany Beach and the coastal towns have grown well beyond their natural limits, yet the towns retain much of their original flavor. Route 26 courses through Millville, which has again become a shopping district for the area. At Ocean View, many of the nineteenth-century homes still stand, and a dedicated group of individuals from the Ocean View Historical Society is working diligently to preserve the memory of the historic coastal towns.

When Route 26 reaches Bethany, it links with Garfield Parkway before ending at the beach. The parkway remains a wide and spacious street. The Loop Canal still ends in a pond near the center of town. Silt has reduced its depth, and boats can no longer make it past Route 1. The Tabernacle is also long gone, having succumbed to the ravages of time and storms half a century ago; in its place, the Christian Church (Disciples of Christ) have built a modern conference center, operated as a nonprofit religious retreat center. The focal point of the conference center is the Tabernacle Building, which is built in the same octagon shape of the original Tabernacle, and it functions much the same as the first building to grace this site. The current Tabernacle

The modern Christian Conference Center now sits on the site of the Tabernacle. *Photo by Michael Morgan.*

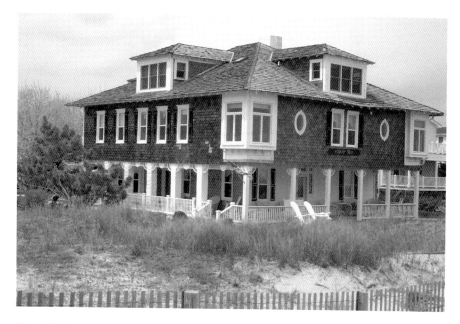

The Addy Sea still welcomes guests. *Photo by Michael Morgan.*

Building, however, has modern facilities that would have made the founders of Bethany Beach envious. It can seat up to 90 persons for meals and up to 125 for meetings. The Tabernacle also has a lounge that seats up to 30 people comfortably. Finally, just as the first Tabernacle featured slide shows and short silent films, the new building is furnished with modern audio-visual and other equipment.

In addition to the Tabernacle, there are several other buildings that are part of the conference center. One of these is the Barton W. Stone House, a classic early "beach house" that was moved to the center several years ago. As with the Tabernacle, this building has been modernized with electricity, heat, air conditioning and other amenities. The renovation of the Barton W. Stone House is typical of what has happened to many of the fine houses built by the early residents of the resort a century ago. The Addy Sea is nestled in the dunes on Atlantic Avenue, serves as a bed-and-breakfast and still contains its original tin ceilings. The Drexler House, where Louis Drexler lived while he worked for better roads and other improvements for the resort, still sits near the beach, but it has been moved back from the ocean three times. In addition, the house has been turned so that the front steps that onetime future naval officers Henry and Louis used for stepping

## Towns Grow Together

The Drexler House now sits well back from the surf. *Photo by Michael Morgan.*

The Journey's End is no longer Fort Maggie. *Photo by Michael Morgan.*

directly into the surf now face inland. Journey's End, which served as "Fort Maggie" during World War II, remains intact, as are houses built by the Errett and Dinker families; several of these structures are now graced with a small marker to indicate their historical importance.

Bethany Beach retains its original low-key character, and it remains a favorite vacation spot for senators, congressmen and other movers and shakers from the Washington, D.C., area. The appearance of the coastal area began to change dramatically during the 1970s with the inauguration of the mammoth Sea Colony project. In addition to a series of high-rises that line the beach south of Bethany, the project extends across Route 1 and includes villas, townhomes, pools, tennis courts and other amenities.

The high-rise buildings at Sea Colony were not the first tall structures to be built on the beach. The two spotting towers of the Fort Miles complex still stand guard on either end of the resort. Following World War II, the fort was declared obsolete; eventually, the gun emplacements and towers reverted to state control. Currently, the Fort Miles Historical Association is working to convert the fort into a World War II museum dedicated to the defenses of the United States. The association is also making a valiant effort to preserve the spotting towers.

The town hall contains a museum with artifacts from the resort's past. *Photo by Michael Morgan.*

# Towns Grow Together

Chief Little Owl watches over the land of the Kuskawaroaks. *Photo by Michael Morgan.*

The architecture of the Bethany Beach Town Hall echoes the octagon shape of the Tabernacle. In addition to housing offices for the operation of the resort's government, the town hall contains a museum that displays memorabilia and photographs that illustrate the history of the resort area. Outside the town hall, in the median of Garfield Parkway, is a wooden sculpture of Chief Little Owl that was carved by Peter Toth. The statue depicts a Nanticoke chief with a north-facing eagle atop his head. The current statue replaced one that was also carved by Toth and put into place in 1976 as part of a project to place totem poles in each of the fifty states and another fifteen in Canada. In 2002, when the current statue was placed, Charles Clark, former assistant chief of the Nanticoke Indian tribe, performed a dedication ritual. The new statue was carved from a red cedar log from Alaska, and it is expected to last up to one hundred years. Every year, several hundred thousand vacationers on their way to the beach pass by the statue of Chief Little Owl, who faces inland and looks pensively over the land of the Kuskawaroaks.

# BIBLIOGRAPHY

## Books

*Annual Reports of the Operations of the United States Life-Saving Service.* Washington, D.C.: Government Printing Office, 1889–1913.

Bishop, N.H. *Voyage of the Paper Canoe.* Whitefish, MT, 2004.

Carter, Dick. *Clearing New Ground: The Life of John G. Townsend Jr.* Wilmington: Delaware Heritage Press, 2001.

———. *The History of Sussex County.* Rehoboth Beach, DE: Community News Corporation, 1976.

*Delaware: A Guide to the First State.* Federal Writers' Project. Dover: Delaware Heritage Press, 2006.

Forbes, Mrs. Walter B. *The Lee Legend and the Shipwreck of the Faithful Steward.* Cypress, CA, 1970.

Gannon, Michael. *Operation Drumbeat.* New York: Harper Perennial, 1990.

Garrison, J. Ritchie, Bernard L. Herman and Barbara McLean Ward, eds. *After Ratification: Material Life in Delaware, 1789–1820.* Newark, DE, 1988.

# Bibliography

Gentile, Gary. *Shipwrecks of Delaware and Maryland*. Philadelphia, PA: Gary Gentile Productions, 1990.

Hancock, Harold B. *Delaware Two Hundred Years Ago: 1780–1800*. Wilmington, DE: Middle Atlantic Press, 1987.

Hayman, John C. *Rails Along the Chesapeake: A History of Railroading on the Delmarva Peninsula, 1827–1978*. Pittsburgh, PA: Marvadel Publishers, 1979.

Hercules Powder Company. *Ditch Blasting: Hercules Dynamite on the Farm*. Wilmington, DE: Hercules Powder Company, 1934.

Hickam, Homer H., Jr. *Torpedo Junction*. New York: Dell Books, 1989.

Hoffecker, Carol E. *Honest John Williams: U.S. Senator from Delaware*. Newark: University of Delaware Press, 2000.

Kimball, Summer L. *Organization and Methods of the United States Life-Saving Service*. Washington, D.C.: Government Printing Office, 1894.

Kyle, Mary Pat. *Fenwick Island, Delaware: A Brief History*. Charleston, SC: The History Press, 2008.

Latrobe, John H.B. *The History of the Mason and Dixon's Line*. Philadelphia: Historical Society of Pennsylvania, 1855.

Lencek, Lena, and Gideon Bosker. *The Beach: The History of Paradise on Earth*. New York: Viking, Penguin Group, Penguin Putnam Inc., 1998.

Ludnum, John. *A History of the Rise of Methodism in America*. Philadelphia, PA: self-published, 1859.

Meehan, James D. *Bethany Beach Memoirs…A Long Look Back*. Bethany Beach, DE: Harold E. Dukes Jr., 1998.

Mills, Eric. *Chesapeake Rumrunners of the Roaring Twenties*. Centreville, MD: Tidewater Publishers, 2000.

# BIBLIOGRAPHY

*Minutes of the Council of the Delaware State, from 1776 to 1792, Papers of the Historical Society of Delaware.* Wilmington: Historical Society of Delaware, 1887.

Munroe, John A. *Colonial Delaware.* Wilmington: Delaware Heritage Commission, 2003.

Nathan, Roger E. *East of the Mason-Dixon Line.* Wilmington: Delaware Heritage Press, 2000.

Noble, Dennis L. *That Others Might Live: The U.S. Life-Saving Service, 1878–1915.* Annapolis, MD: Naval Institute Press, 1994.

*Official Minutes of the Delaware Conference of the Methodist Church, March, 1908.* Philadelphia, PA: published by the Methodist Episcopal Church, 1908.

Philadelphia, Wilmington and Baltimore Railroad Company. *A Paradise for Gunners and Anglers.* Philadelphia, PA: self-published, 1883.

Scharf, J. Thomas. *History of Delaware, 1609–1888.* Philadelphia, PA: J.L. Richards and Co., 1888.

Seibold, David J., and Charles J. Adams. *Shipwrecks, Sea Stories & Legends of the Delaware Coast.* Barnegat Light, NJ: Exeter House Books, 1989.

Shanks, Ralph, and Wick York. *The U.S. Life-Saving Service: Heroes, Rescues and Architecture of the Early Coast Guard.* Edited by Lisa Woo Shanks. Petaluma, CA: Costano Books, 1998.

Smith, John. *The Generall Historie of Virginia, New England and the Summer Isles.* Glasgow, Scotland: James MacLehose and Sons, 1907.

*Southern Historical Society Papers* 2, no. 1. "William P. Zollinger, Lamar Hollyday, D. Howard to Rev. J. William Jones, Secretary of the Southern Historical Society, July 19, 1876" (1876).

Trapani, Robert, Jr. *Indian River Life-Saving Station…Journey Along the Sands.* Virginia Beach, VA: Delaware Seashore Foundation, 2002.

Vincent, Francis. *A History of the State of Delaware*. Philadelphia, PA: John Campbell, 1870.

Warrington, C.W. *Delaware's Coastal Defenses: Fort Saulsbury and a Mighty Fort Called Miles*. Wilmington: Delaware Heritage Press, 2003.

Weslager, C.A. *Delaware's Buried Past: A Story of Archaeological Adventure*. New Brunswick, NJ: Rutgers University Press, 1968.

———. *Delaware's Forgotten Folk: The Story of the Moors & Nanticokes*. Philadelphia: University of Pennsylvania Press, 1943.

Weslager, C.A., and Louise Heite. "History." In *The Delaware Estuary: Rediscovering a Forgotten Resource*, edited by Tracey L. Bryant and Jonathan R. Pennock. Newark: University of Delaware Sea Grant College Program, 1998.

Williams, William H. *Slavery and Freedom in Delaware, 1639–1865*. Wilmington, DE: Scholarly Resources, 1996.

Willoughby, Malcolm. *The U.S. Coast Guard in World War II*. Manchester, NH: Arno Press, 1980.

Wilson, E. Emerson. *Forgotten Heroes of Delaware*. Cambridge, MA: Deltos Publishing, 1970.

# NEWSPAPERS

*Baltimore Sun*, October 5, 1952.
*Bath Daily Times*, September 5, 1944.
*Bethany Beach Booster*, September, 1912, vol. 1, no. 4; September, 1913, vol. 2, no. 5.
*Delaware Beachcomber*, July 12, 1996.
*Delaware Coast News*, August 2, 1935; December 12, 1941; January 30, 1942.
*Delaware Coast Press*, March 5, 1997; February 11, 1998; February 27, 2002.
*Delaware Wave*, December 30, 1994; December 14, 1994.
*Maryland Gazette*, September 22, 1785.
*Milford Chronicle*, April 20, 1917; May 4, 1917.

*New York Times*, April 11, 1907; August 12, 1909; August 24, 1933; July 25, 1943; August 3, 1952.
*Pennsylvania Packet*, September 12, 1785.
*Salisbury Times*, March 14, 1942.

## Periodicals

Benson, Barbara E. "Delaware Goes to War." *Delaware History* 26, no. 3–4 (Spring–Summer 1995, Fall–Winter 1995).

Chapple, Joe M. "Wireless Telegraphy." *National* magazine 26 (May 1907).

Cox, S.S. "The Life Saving Service." *North American Review* (May 1881).

Doughty, Frances Albert. "Life at a Life-Saving Station." *Catholic World* 65, no. 388 (July 1897).

Eissenbrown, Joseph D., Major. "The 213th CA (AA) Pa. N.G. at Bethany Beach, Delaware." *Coast Artillery Journal* 71, no. 4 (October 1929).

Hancock, Harold. "A Loyalist in Sussex County: The Adventures of J.F.D. Smyth in 1777." *Delaware History* 16, no. 4 (Fall–Winter 1975).

———. "William Morgan's Autobiography and Diary: Life in Sussex County, 1780–1857." *Delaware History* 19, no. 1 (Spring–Summer 1980).

Jordan, John W. "Penn *Versus* Baltimore, Journal of John Watson, Assistant Surveyor to the Commissioners of the Province Of Pennsylvania, December 13–March 18, 1750/51." *Pennsylvania Magazine of History and Biography* 39, no. 1 (1915).

Little Owl (Charles C. Clark IV). *The Nanticoke, Heartland of Del-Mar-Va* (Sunshine 1987).

Merryman, James H. "The United States Life-Saving Service." *Scribners Monthly* 19, no. 3 (January 1880).

# Bibliography

Moyer, E.C.A. "A Summer Lodge of Sigma Alpha Epsilon." *Record* 24, no. 1 (March 1904).

Power, F.D. "Bethany Beach as Seen from the Dome." *Christian Worker* (September 29, 1905).

Sebold, Kimberly R. "The Delmarva Broiler Industry and World War II: A Case in Wartime Economy." *Delaware History* 25, no. 3 (Spring–Summer 1993).

Stark, H.W., Lieutenant Colonel. "The 198$^{th}$ Wins Association Trophy." *Coast Artillery Journal* 83, no. 2 (March–April 1940).

Tunnel, James M., Jr. "The Salt Business in Early Sussex County." *Delaware History* 4, no. 1 (March 1950).

Warren, T. Robinson. "Bay Shooting." *Scribner's Monthly* 13, no. 2 (December 1876).

## Websites

Archives of Maryland Online. Proceedings of the Council of Maryland. Vol. 28 http://www.msa.md.gov/megafile/msa/speccol/sc2900/sc2908/000001/000028/html.

———. Proceedings of the Council of Maryland. Vol. 31 http://www.msa.md.gov/megafile/msa/speccol/sc2900/sc2908/000001/000031/html/index.html.

Bethany Beach Landowners Association. *A Walk Through History, 1901–1976.* http://www.bethany-beach.net/history.htm.

Cary, Dr. Wendy, and Dr. Robert Dalrymple. "Northeasters." *Coastal Currents.* http://www.deseagrant.org/sites/deseagrant.org/files/product-docs/coastal_currents_northeasters.pdf.

"Citizens of Delaware Who Served the Confederacy." The Delaware Grays. http://www.descv.org/DelawareConfederates.html.

# Bibliography

Delaware State Parks. Assawoman Canal. http://www.destateparks.com/park/holts-landing/assawoman-canal.asp.

*Dictionary of American Naval Fighting Ships*, vols. 4 and 7. http://www.hazegray.org/danfs.

Elmwood, Bob. Faithful Steward website. http://freepages.genealogy.rootsweb.ancestry.com/~faithfulsteward.

Espy, Florence Mercy. *History and Genealogy of the Espy Family in America.* Madison, IA, 1905. http://www.archive.org/stream/historygenealogy00espy/historygenealogy00espy_djvu.txt.

Herbert Hoover Presidential Library & Museum. "During the 1928 presidential campaign…." http://hoover.archives.gov/info/faq.html#chicken.

Jazz Funeral, Bethany Beach, DE. "History." http://www.jazz-funeral.com/history.html.

National Park Service. *Lighthouses: An Administrative History.* Maritime Heritage Program. http://www.nps.gov/history/maritime/light/admin.htm.

Naval Historical Center. "German Espionage and Sabotage Against the U.S. in World War II: Eastern Sea Frontier War Diary Account of German Agents Landing." http://www.history.navy.mil/faqs/faq114-3.htm.

———. "USS *Trenton* (CL-11), 1924–1946." http://www.history.navy.mil/photos/sh-usn/usnsh-t/cl11.htm.

Newspaper Abstracts. *Philadelphia Inquirer*, October 24, 1903, http://www.newspaperabstracts.com/link.php?action=detail&id=53982; *Philadelphia Inquirer*, August 6, 1910, http://www.newspaperabstracts.com/link.php?action=detail&id=61363; and *Philadelphia Inquirer*, August 24, 1913, http://www.newspaperabstracts.com/link.php?action=detail&id=52900.

Overfalls Maritime Museum Foundation. http://www.overfalls.org.

Rootsweb. "U-117." http://freepages.military.rootsweb.ancestry.com/~cacunithistories/U_117.html.

———. "USS Minnesota BB-22." http://freepages.military.rootsweb.ancestry.com/~cacunithistories/USS_Minnesota.html.

State of Delaware. "History of the Assawoman Canal Dredging Project." http://www.dnrec.delaware.gov/Assawoman/Pages/ACDPHistory.aspx.

University of Delaware Daily Archive. "March 1962 Storm Devastated Delaware Beaches." http://www.udel.edu/PR/UDaily/01-02/marchstorm030802.html.

# ABOUT THE AUTHOR

Michael Morgan has been writing freelance newspaper articles on the history of Rehoboth Beach and the mid-Atlantic region for more than three decades. He is the author of the "Delaware Diary" weekly column in the *Delaware Coast Press*, and the "Sussex Journal," which is a weekly feature of the *Wave*. Morgan has also published articles in the *Baltimore Sun*, *Maryland* magazine, *Chesapeake Bay* magazine, *Civil War Times*, *World War II* magazine, *America's Civil War* and other national publications. A frequent lecturer in the coastal region, Morgan's look at history is marked by a lively storytelling style that has made his writing and lectures popular. Michael Morgan is also the author of *Pirates and Patriots: Tales of the Delaware Coast*, which captures the broad panorama of the history of the coastal region, and *Rehoboth Beach: A History of Surf and Sand*, which tells the story of Bethany's neighbor to the north.

Photo by Madelyn Morgan.

Visit us at
www.historypress.net